MURDER
IN THE
MIDLANDS

MURDER
IN THE
MIDLANDS

LARRY GENE BELL & THE 28 DAYS OF TERROR THAT SHOOK SOUTH CAROLINA

by forensic photographer

Rita Y. Shuler

THE
History
PRESS

Published by The History Press
Charleston, SC 29403
www.historypress.net

Cover image: Bell's booking photo the morning of his arrest. *Courtesy of SLED.*

First published 2007
Manufactured in the United States

ISBN 978.1.59629.250.5

Library of Congress Cataloging-in-Publication Data

Shuler, Rita Y.
Murder in the midlands : Larry Gene Bell and the 28 days of terror that
shook South Carolina / Rita Y. Shuler.
p. cm.
Includes bibliographical references.
ISBN 978-1-59629-250-5 (alk. paper)
1. Bell, Larry Gene, 1948-1996. 2. Murder--South Carolina--Case studies.
3. Murderers--South Carolina--Case studies. 4. Trials (Murder)--South
Carolina. 5. Smith, Sharon Faye, d. 1985. 6. Helmick, Debra May, d. 1985.
7. Murder victims--South Carolina--Case studies. I. Title.
HV6533.S6 S583 2007
361.152'3092--dc22
2007000638

Dedicated to the memory of Shari Faye Smith and Debra May Helmick.

CONTENTS

ACKNOWLEDGEMENTS

This is a case that is permanently etched in South Carolina's history. Some segments of interviews, court transcripts and published articles have been edited to facilitate reading.

First, my sincere thanks to everyone at The History Press for their professional and personal assistance with my first book, *Carolina Crimes*, and now with *Murder in the Midlands*.

My deepest thanks again to my dear friend, Kathleen Thornley, for her support and proofreading to help me bring it all together, and to my family and friends for their help and support along the way.

My special thanks to my fellow SLED Agent and friend Diane Bodie for her advice, our many conversations, "crime stories" and margaritas.

My heartfelt thanks to Debra (Helmick) Johnson, Woody, Becky, Little Debra and Little Woody for being devoted friends and sharing their personal memories.

Thanks to former and present SLED agents and some who have passed on for relevant information of the case: Lieutenant Ken Habben, Captain Leon Gasque, Lieutenant Jim Springs, Lieutenant "Skeet" Perry, Lieutenant Hoss Horton, Lieutenant Gaile Heath, Captain David Caldwell and Special Agent Dan DeFreese.

My appreciation to the following for assisting me with obtaining the investigative case files, court transcripts and other significant information: SLED agents and personnel; Captain Teresa Woods; Lieutenant Mike Brown; Mary Perry; Sabrena Matthews; Cindy Dudley; Tammy Rawl;

ACKNOWLEDGEMENTS

Solicitor Donnie Myers from the Lexington County Solicitor's Office; Chief Deputy Attorney General Don Zelenka and librarian Susan Husman from the office of the attorney general of South Carolina; Sheriff James Metts, Lexington County Sheriff's Office; and Dr. Ted Rathbun, forensic physical anthropologist.

AUTHOR'S NOTE

C ases should not be remembered for the persons who did the crime. That would only glorify those persons. We should always remember the victims and keep the awareness that bad and evil continue to happen.

Truth is very important in life. This case is a South Carolina truth, maybe one that we would prefer not to claim, but it is real and it did happen. It should be remembered so that Shari Faye Smith and Debra May Helmick will never be forgotten.

As with all the cases I assisted with during my twenty-four years with the South Carolina Law Enforcement Division (SLED), I always felt and trusted that what I was doing would help give some comfort to the families and loved ones left behind.

I tell this story with sincere compassion and respect for all involved.

28 DAYS OF TERROR

 My early morning four-mile run felt good. I've always loved mornings, the start of another day to love life. It was already seventy-five degrees and another picture-perfect day at Edisto Beach, South Carolina. Edisto Beach is one of the last unspoiled beaches on South Carolina's coast with a laid-back atmosphere and Southern charm.

There was an extreme heat wave going through South Carolina, with temperatures hitting one hundred degrees for the last several days. This was one of my getaway R&R weekends away from work. I was 160 miles from SLED headquarters in Columbia, and everything was right with my world.

Just the day before, Friday, May 31, 1985, even though the temperature was one hundred degrees, the sky had been a beautiful vivid blue, not a cloud anywhere. The conditions for crabbing were perfect. I had spent most of the day on Bay Creek Inlet holding onto a line with a chicken back hooked on the end with a metal shower curtain hook, pulling in blue crabs. I caught about four dozen of those big boys. It was a good day's catch.

Today would be another good day for crabbing, but first I had to make a supply run to the corner IGA grocery store. I needed to get more chicken backs for bait and, of course, beer and ice. Crabs always seem to bite better when there's beer around.

My only thought right then was to get back to the crabs, so I rushed to the IGA, jumped out of my Jeep and hurried to the door. I did a quick glance at the newspaper rack right outside the door and stopped dead in my tracks. The bold headlines of the *State* newspaper read, "Missing Teenager Feared Abducted," and accompanying the headline was a photo of Sharon "Shari" Faye Smith. I leaned down, grabbed it out of the rack and started reading:

> *Car found in driveway, door open, and engine running. Sheriff Deputies and volunteers conducted an air and ground search of a wooded area of rural Lexington County Friday for a 17-year-old high school senior feared abducted after her car was found abandoned in the driveway of her family's home in the rural community of Red Bank on Platt Springs Road, ten miles from Lexington, South Carolina. Shari's parents found Shari's blue Chevette at the end of their driveway around 3 p.m. Friday. The door was open and the engine was running. Bare footprints were found leading from the car to the mailbox, but no return tracks to the car were found. Lexington County Sheriff James Metts stated, "Nobody saw anything. We have no clues. She vanished."*

Sheriff Metts requested the assistance of the South Carolina Law Enforcement Division (SLED).

As I left Edisto Island Sunday morning heading back to Columbia, I picked up the Sunday *State* paper. The search for Shari was again front-page news.

The search had continued on Saturday in the one-hundred-degree blistering heat for the missing teenager from Lexington. It took on an added urgency when it was learned that Shari had a rare form of diabetes, diabetes insipidus, commonly know as water diabetes. This type of diabetes required that Shari drink large quantities of water and take her prescribed medication.

Shari always stopped and checked the mail on her way into the house. Around 3:25 p.m. on Friday, May 31, her mother had glanced out of the window of her home and saw Shari's car in the driveway at the road near the mailbox and told her husband, Bob, that Shari was home.

Minutes later, Mr. Smith looked out the window and saw Shari's car still parked at the road. He became concerned when his daughter did not continue up the 750-foot driveway to the house, and he could see no sight of her around the car or mailbox. He rushed to his car and drove down to

The State

South Carolina's
Largest Newspaper

Columbia, South Carolina — Saturday, June 1, 1985

94th Year — No. 152
• 3 Sections — 44 Pages

Missing teenager feared abducted

**Car found in her driveway;
door open, engine running**

By BOBBY BRYANT
and DEBRA-LYNN BLEDSOE
State Staff Writers

Sheriff's deputies and volunteers conducted an air and ground search of a wooded area of rural Lexington County Friday for a 17-year-old high school senior feared abducted after her car was found abandoned in the driveway of her family's home.

A family member found Shari Smith's blue Chevette, the door open and engine running, parked in the driveway shortly after 3 p.m., according to Lexington County Sheriff James R. Metts.

The house is on Platt Springs Road, about a mile past S.C. 6 in the Red Bank community.

The teenager was wearing a swimsuit at the time she disappeared and apparently was barefoot, Metts said. Deputies found footprints leading from the car to the mailbox by the road, but no return tracks, he said.

At 10:30 p.m., Metts said searchers had found a red bandana belonging to Miss Smith on Platt Springs

Road leading away from West Columbia.

Earlier in the night, Metts said authorities had no clues to Miss Smith's disappearance.

"Nobody saw anything. We have nothing," he said. "She vanished."

There was no evidence to indicate the teenager had been kidnapped, Metts said, "but it's the only logical alternative."

The sheriff said he had received reports of two suspicious vehicles in the area, but there was no

See Girl, 9-A

Shari Smith

Front-page headlines, Saturday, June 1, 1985. *Courtesy of the* State.

Sharon "Shari"
Faye Smith.
*Courtesy of
SLED.*

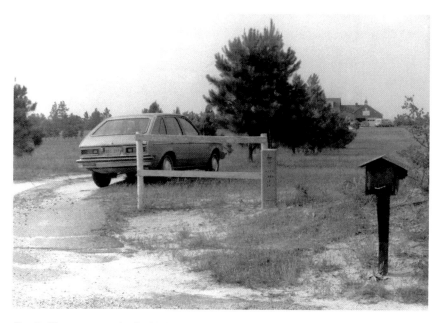

Shari's Chevette near the Smiths' mailbox. *Courtesy of Solicitor Donnie Myers.*

check on her. He called to her as he got out of the car but got no response. He did not see his daughter anywhere. The car was running and the door on the driver's side was open. Shari's purse, towel and black jelly shoes were in the car. He opened her purse and saw that her medication was inside. He knew Shari never went anywhere without her medication. His greatest fear was confirmed: Shari was missing.

Mr. Smith raced back to the house and yelled to his wife that Shari was gone. Frantically he picked up the phone and dialed the Lexington County Sheriff's Office.

Mrs. Smith ran out the door and got in the car. She sped up to the end of the driveway, jumped out and walked back and forth screaming Shari's name. Knowing her daughter, she knew she was probably nowhere around since she did not answer. She knew that Shari had vanished.

Law enforcement officers responded immediately to the Smiths' home. Air teams were called in for the search, and the Emergency Preparedness Division of the governor's office set up a tractor-trailer operation center in front of the Smiths' house. The trailer was equipped with radios, telephones and twenty-four-hour coverage. This enabled law enforcement officers to accomplish tasks faster rather than having to travel back and forth to the law enforcement centers.

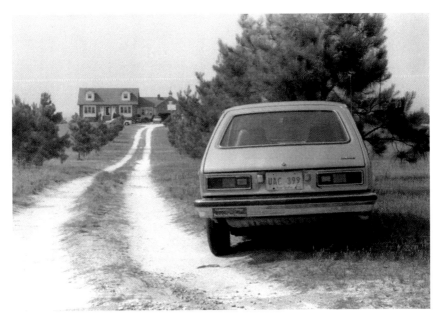

Shari's Chevette at the end of the Smiths' driveway. *Courtesy of Solicitor Donnie Myers.*

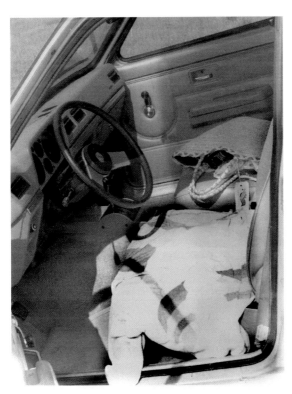

The driver's door was open when Mr. Smith got to Shari's car. Her purse and towel were on the front seat. *Courtesy of Solicitor Donnie Myers.*

The Smiths' spirits were uplifted at one point on Saturday when they received a phone call from a man saying, "I have Shari. I want money." This was only to be shot back down when the call turned out to be a hoax.

Officers began checking out calls of sightings of suspicious vehicles in the area around the time of the incident. One call was from two males who had traveled on Platt Springs Road between 3:00 and 3:15 p.m. that Friday afternoon. As they passed the Smith residence, they saw Shari at her mailbox and the car in the driveway. They remembered a car coming toward them going in the direction of the Smith driveway, and as the car passed, the witness glanced in his rearview mirror. He saw the taillights of the passing car light up and the car stop at the Smiths' mailbox. They said it looked like an '82 or '84 Oldsmobile Cutlass, reddish-purple in color, and the driver looked like he was in his thirties. In approximately five to ten minutes, the two males drove back past the mailbox. They saw Shari's car but did not see Shari.

Shari's boyfriend, Richard, had met Shari at the Lexington Post Office in downtown Lexington on Friday morning. Together they met Shari's mother at a Lexington bank around 11:15 a.m. to get travelers' checks for Shari to take on her senior trip to the Bahamas after her graduation that Sunday.

After her mother left, Richard, Shari and their friend Brenda parked their cars in the Lexington Town Square Shopping Center parking lot around 11:30 a.m. and rode together to a swimming party at Lake Murray just a few miles away.

Shari was wearing white baggy shorts and a yellow tank top over her yellow-and-black dot two-piece swimsuit. She had a beach bag packed with an extra bathing suit, towel, black jelly shoes and a white-and-black striped shirt she had worn to school that day.

Shari called her mother from the party around 2:30 p.m. Shortly afterward, around 2:45 p.m., Shari, Richard and Brenda left the party and drove back to the shopping center parking lot to pick up their cars.

Brenda left, and Richard and Shari spent a few minutes together in the parking lot talking. They kissed goodbye and departed in separate cars.

Richard followed Shari until she turned down Highway 1 heading toward her home. As he went past the bank clock in the parking lot, he noticed the time as 3:05 p.m.

Sunday, June 2, was to be Shari's big day. She was to graduate from Lexington High School and was scheduled to sing "The Star-Spangled Banner" with her classmate, Andy Anu.

I knew this case would be waiting on me when I returned to work that Monday morning. It was the last thing I thought about before finally going to sleep that night, and it was the first thing that entered my mind as I opened my eyes the next morning.

The early morning was silent and peaceful as I stepped out the door for my morning run before work. This morning, with every step pounding on the pavement, my thoughts were on Shari Smith's disappearance. It was around 6:45 a.m. when I got back from my run. As I opened my front door, the phone was ringing. The caller was Lieutenant Jim Springs, SLED latent print crime scene investigator.

I worked so closely with the crime scene investigators that they all knew my morning routine of a run before work. Jim was hastening, "Rita, I guess you were out running. I've been calling. We need you at headquarters ASAP to photograph a letter involving the Shari Smith disappearance. The letter has been intercepted at the post office and is being delivered to SLED as we speak."

Within minutes I was showered, dressed and walking into headquarters. The letter had arrived by the time I got there. Specialized photography was imperative to document the original form of the letter and envelope before any scientific analysis could be performed.

As I was photographing the letter, Lieutenant Springs told me of some of the events surrounding the call and letter. A call had come into the Smiths' house around 2:20 a.m. that morning, Monday, June 3, informing them that they would be getting a letter in the mail today from Shari around one or two o'clock. That was the usual time the Smiths' mail was delivered. The male caller's voice sounded muffled and disguised. He told Mrs. Smith that he wanted to give them some information and tell them certain things so that they would know this was coming from Shari and that the call was not a hoax. He described in detail the outfit that Shari was wearing when Mrs. Smith last saw her at the bank and the shopping center. He told them at the top of the letter would be 6/1/85, and the time would be 3:10 a.m. He said it had really been 3:12 a.m., but he had rounded it off. He ended with, "They are looking in the wrong place. Tell Sheriff Metts to get on TV at 7:00 a.m. on Channel 10 and call off the search."

The Smiths now knew that this must be the man who had Shari. No ransom demands were made, so money did not appear to be the issue for the caller. The call was not recorded, but Mrs. Smith took notes as the man talked.

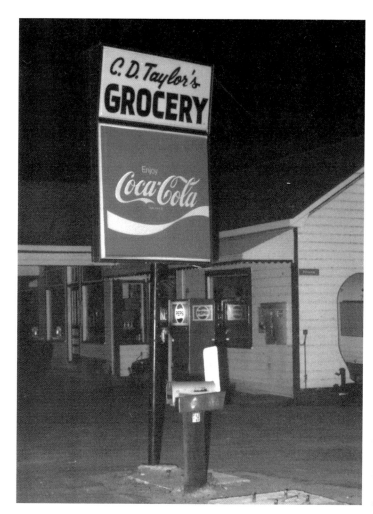

The call informing the Smiths of Shari's letter was traced to a pay phone outside Taylor's Store, about twelve miles from the Smiths' residence. *Courtesy of SLED.*

Envelope of Shari's "Last Will and Testament." *Courtesy of SLED.*

The call was traced through Alltel telephone records to a pay phone outside of Taylor's Store on Highway 378, about five miles outside of Lexington and twelve miles from the Smiths' home. The caller had vanished by the time officers arrived at the location. The telephone was processed for prints, but no identifiable prints or useful evidence was found.

The Lexington County postmaster, Thomas Roof, was alerted and met Officers J.E. Harris and Richard Freeman with the Lexington County Sheriff's Office at about 4:00 a.m. Monday morning at the Lexington Post Office. Mr. Roof allowed them to sort through all of the Lexington addressed mail in the post office and the bag of Lexington addressed mail that had arrived from the Columbia distribution post office earlier that morning. In the bag from Columbia they found a letter addressed to the Smith family. The letter was found at approximately 7:00 a.m., and Shari's father was transported to the post office to take delivery of the letter.

It was a white legal-sized envelope. The Smith family address was written on a small loose-leaf, pocket-sized, blue-lined sheet of paper approximately three and a half by five inches, the size notepaper in a notebook that would fit in your pocket. The sheet was pasted to the envelope. It was postmarked June 1, 1985, in Columbia and had a twenty-two-cent mallard duck stamp in the upper-right corner. There was no return address. Inside the envelope were two sheets of blue-lined yellow legal paper eight and a half by eleven inches in size bearing handwriting and printing.

After photographic documentation of the letter, Lieutenant Mickey Dawson with the SLED Questioned Document Unit examined the letter, which was titled "Last Will and Testament" and dated 6/1/85 at 3:10 a.m. Dawson compared the handwriting in the letter to known handwriting of Shari Smith and positively identified the letter to be in Shari's handwriting. The letter appeared to be a farewell.

When a person vanishes, there are always unanswered questions. Is the family involved? Did she leave on her own? Was she a runaway? Was she abducted? How could she simply just disappear into thin air?

Shari leaving on her own was certainly a possibility at this point, but with her rare form of diabetes, she would never leave her essential medication behind. Shari was to graduate on Sunday and after that she and her classmates were to go on a cruise. She had every reason to stay.

Lieutenant Dawson and SLED Questioned Document Examiner Gaile Heath processed the envelope and letter on the Electrostatic

6/1/85 3:10 AM I Love ya'(!)

Last Will & Testament

G
O
D
i
S

l
O
V
E

in

Shari Richard
♡

I Love you Manny, daddy, Robert, Dawn, + Richard and everyone else and all other friends and relatives. I'll be with my father now, so please, please don't worry! Just remember my witty personality + great special times we all shared together. Please don't even let this ruin your lives just keep living one day at a time for Jesus. Some good will come out of this. My thoughts will always be with + in you... (casket closed) I love you all so damn much. Sorry dad, I had to cuss for once! Jesus forgave me! Richard sweetie - I really did + always will love you + treasure our special moments.. I ask one thing though, accept Jesus as your personal savior. ☺ My family has been the greatest influence of my life. Sorry about the cruise i more. Somebody please go in my place. →

Page one of the "Last Will and Testament." *Courtesy of SLED.*

I am sorry if I ever disappointed you in any way, I only wanted to make you proud of me. Because I have always been proud of my family. Mom, dad, Robert & Dawn there so much I want to say that I should have said before now. I love you!

I know y'all love me and will miss me very much but if y'all stick together like we always did - y'all can do it!

Please do not become hard or upset. Everything works out for the good for those that love the Lord.

☺

I love y'all / w/ All My Heart. • All My Love Always - Sharon (Shawn) Smith

P.S. Nana - I love you so much. I kind of always felt like your favorite. You were mine. I love you alot

Page two of the "Last Will and Testament." *Courtesy of SLED.*

Detection Apparatus (ESDA). The ESDA is an instrument that develops indented writings from paper products. It works on the opposite principle of a printing press. Instead of coating raised letters with ink to create an image, the ESDA fills in the indentations on the document in question with graphite particles called "carrier particles." When an imaging film similar to Saran Wrap is pulled tight over the document, a readable image can possibly come through, making the indentations legible in varying degrees in such a manner that the indentations may be captured in hard copy form and the information from these indentations made available for investigative use.

In this case, if anything was written on the sheets of the legal pad before the sheet where Shari wrote her "Last Will and Testament," there was the possibility that the pressure of the pen or pencil would make the indentations go through to her sheet.

The product of the ESDA process disclosed numerous indentations on the first page of the "Last Will and Testament." There were faint impressions of numbers that had the appearance of telephone numbers. Other faint indentations on the document appeared to be "Bob" with a circle around it, "beef sticks," "Mother" and the letters "J" and "S."

The envelope and "Last Will and Testament" were then processed for trace evidence (any material from the body or foreign materials around the body).

After completion of the photography, questioned document and trace evidence examinations on the envelope and "Last Will and Testament," Lieutenant Jim Springs processed the documents for latent prints. Numerous prints were developed on both pages of the letter. I photographed and printed a one-to-one-ratio exact size photograph of each.

Lieutenant Springs' results of the comparison of the latent prints from the letter to Shari's known prints were as follows:

On page one, one latent print was positively identified as the right ring finger of Sharon Faye Smith; two latent prints were positively identified as the right thumb of Sharon Faye Smith; and one latent palm print was positively identified as the right palm of Sharon Faye Smith.

On page two, one latent print was positively identified as the right thumb of Sharon Faye Smith.

The envelope did not yield any prints suitable for comparison.

Another phone line was set up for incoming and outgoing calls at the Smith home. After the first call, in the early morning of June 3, a recording device was placed on their personal phone line, and the line was to remain open in the event the caller should call again.

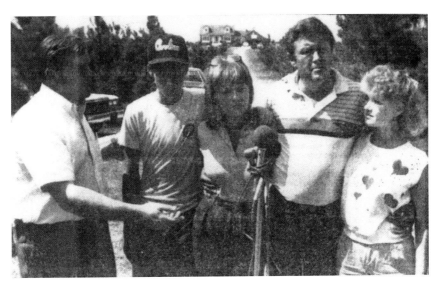

Sheriff Metts and the Smith family in front of their home, pleading for Shari's return. *Left to right*: Sheriff Metts; Shari's brother, Robert Jr.; Mr. and Mrs. Smith; and Shari's sister, Dawn. *Courtesy of the* State.

That Monday afternoon, June 3, at 3:08 p.m., a second call came into the Smiths' home. The Smiths' older daughter, Dawn, answered. "Hello."

"Mrs. Smith."

"No, this is Dawn."

"I need to speak to your mother."

"Could I ask who's calling?"

"No."

"Ok, ok, hold on just a second please."

(Lapse of a few seconds)

"Hello."

"Have you received the mail today?"

"Yes, I have."

"Do you believe me now?"

"Well, I'm not really sure I believe you because I haven't had any word from Shari, and I need to know that Shari is well."

"You'll know in two or three days."

"Why two or three days?"

"Call the search off."

"Tell me if she is well because of her disease. Are you taking care of her?"

At that point the line went dead.

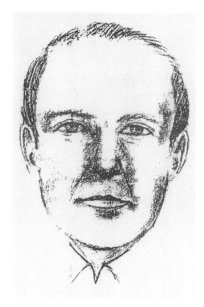

Composite of Smith suspect. *Courtesy of SLED.*

The call was traced to an outside pay station at Eckerd's pharmacy in the Lexington Town Square Shopping Center, which is about seven miles from the Smiths' home. As with the first call, the caller was gone by the time officers arrived at the location, and no identifiable prints or evidence were found.

Later that Monday afternoon, the Smith family appeared in front of their home and spoke to reporters for the first time since Shari's disappearance. They hoped that showing their pain and suffering might draw their daughter's abductor out and he would give Shari up. They pleaded for her return. "Whoever has our daughter, Shari, we want her back. We miss her. We love her. Please send her back home. She belongs here with us."

The search continued. Volunteers brought in food and drinks. The local electric company sent in their crews to set up temporary lines to emergency equipment. The search was extended throughout South Carolina, and a nationwide alert to all law enforcement agencies was launched.

All possible leads that came in were checked out. A call was received from Mrs. Terry Butler, who had driven by the Smith house at about 3:30 p.m. the Friday Shari was abducted. She reported seeing Shari's car pull into the driveway near the mailbox. After passing the Smiths' driveway, she met another vehicle headed over into her lane of traffic. She looked directly at the driver and started blowing her horn. The driver of the other car looked up quickly and pulled back into his lane of traffic. It appeared that he was leaning over in the middle of his seat and not looking at the road. Startled, she watched this car in her rearview mirror. The brake lights came on and the car pulled off the road near the Smiths' mailbox. Mrs. Butler gave a physical description of the driver as best she remembered. She assisted officers in preparing a facial composite of the man, describing him as a white male, cleanshaven, receding thin hair or

slightly balding. Her description of his car corresponded to the description that was previously reported by the other two persons in the area of the Smiths' driveway around the same time that Friday.

The phone rang at the Smith house that Monday night around 8:07 p.m. Again, Dawn grabbed it. "Hello."

"Dawn, did you come down from Charlotte?"

"Yes, I did. Who's calling please?"

"I need to speak with your mother."

"Ok, she's coming."

"Tell her to hurry."

"She's hurrying. Tell Shari I love her."

"Did y'all receive her letter today?"

"Yes we did. Here's mother."

"This is Hilda."

"Did you receive Shari Rae's [*sic*] letter?"

"Pardon? I can't hear you. It's not very clear. Speak louder."

"Did you receive the letter today?"

"Uh, yes, I did."

"Tell me one thing it said. Hurry."

"Shar Richard."

"Do what?"

"There was a little heart on the side, Shar Richard, written on the side."

"How many pages?"

"Two pages."

"Ok, and it was a yellow legal pad?"

"Yes."

"And on one side of the front page, it said, 'Jesus is love?'"

"No, God is love."

"Well, God is love."

"Right."

"Ok, so you know now this is not a hoax call?"

"Yes, I know that."

"I'm trying to do everything possible to answer some of your prayers, so please in the name of God, work with us here."

"Can you answer me one question, please. You...you are very kind... and, and you seem to be a compassionate person and...and I think you know how I feel being Shari's mother and how much I love her. Can you tell me? Is she all right physically without her medication?"

"Shari is drinking a little over two gallons of water per hour and using the bathroom right afterward. I've got to hurry, now. Ok, now, this has gone too far. Please forgive me. Have an ambulance ready at anytime at your house. And on Shari's request, she requests that only immediate family come and Sheriff Metts and the ambulance attendants. She don't want to make a circus out of this."

"Right. Ok."

"And where she said 'casket closed' in parentheses…if anything happens to me, she said her…one of her requests she did not put in there was to put her hands on her stomach…cross her hands like she was praying in the casket."

"We don't want any harm to you. I…I promise. We just want Shari well and all right, ok?"

"Ok, listen. Listen real carefully. I've got to hurry. I know these calls are being traced, correct? Ok, now listen."

"Uh, is Shari with you or can you tell me that?"

"I will not say. Ok, now listen to us, please. You're looking in the wrong place. Forget Lexington County. Look in Saluda County. Do you understand?"

"Look in Saluda County?"

"Exactly. Uh, closest to Lexington County within a fifteen-mile radius right over the line…is that understood?"

"Yes."

"Well, tell Sheriff Metts that he…I don't know what the problem is. I told you to forget about looking around your house…Saluda County."

"Listen, there are so many people that love Shari, and they just won't give up."

"I want to tell you one other thing. Shari is now a part of me, physically, mentally, emotionally and spiritually. Our souls are now one."

"Your souls are one now with Shari?"

"And she said she does love y'all and like she said, do not let this ruin your lives…and well, time's up and please now have the ambulance ready at any time."

"Is her condition getting bad? Is that what you're trying to tell…"

"Just have the ambulance, and I'll give you the location and tell Sheriff Metts to get all his damn men in Saluda County. Ok, well, God bless all of us."

"Will you call me soon?"

"I will. I've got to be careful. I've got to go now, and, and listen. Please, please, please forgive me for this. It just got out of hand."

"Just tell Shari…I know she knows how much I love her. Tell her, her Daddy loves her and her brother and sister love her. God bless you for taking care of her."

"Shari is protected, and like I said, she is a part of me now, and God looks after all of us. Goodnight."

"Good luck to you, too."

This call was traced to a pay station located at the Wall Street Store at Interstate 20 and Highway 204, about eight miles from the Smiths' home. As twice before, he was not there when officers arrived, and no evidence was found.

The Smith family and concerned citizens offered a reward for Shari's return. The Smiths' home was guarded around the clock with officers inside and outside the house. Richard, Shari's boyfriend, was also staying at the Smiths' home. They were not allowed out of their house unless accompanied by a law enforcement officer.

Tuesday, the fourth day after Shari's disappearance, Shari's mother issued a second appeal. This one was directly to her daughter, urging her not to give up hope. "Shari, we're still looking for you. We need you. We love you. Come home to us."

On that same day, June 4, at 9:45 p.m., the phone rang again. Dawn ran down the stairs and answered it. "Hello."

"Dawn?"

"Yes."

"This is Shari Faye's request. Have your mother get on the other phone quickly."

"Get to the other phone, mother."

"Get a pencil and paper ready."

"Get a pencil and paper ready, ok. Mother's not on the phone yet."

"Ok, now this is Shari's own words. So listen carefully. Say nothing unless you're asked. Ok, and I know these calls are taped and traced, but that's irrelevant now. There's no money demanded, so here's Shari Faye's last request. On the fifth day to put the family at rest…Shari Faye being freed. Remember we are one soul, now. When located, you'll locate both of us together. We are one. God has chosen us. Respect all past and present requests. Actual events and times…jot this down."

"All right, I'm doing it."

"3:28 in the afternoon, Friday, thirty-first of May, Shari…Shari Faye was kidnapped from your mailbox with a gun. She had the fear of God

in her, and she was at the mailbox. That's why she did not return back to her car."

"Fear of God?"

"Ok, 4:58 a.m…no, I'm sorry. Hold on a minute. 3:10 a.m., Saturday, the first of June, uh, she hand wrote what you received. 4:58 a.m., Saturday, the first of June…became one soul."

"Became one soul. What does that mean?"

"No questions now. Last, between four and seven Wednesday, tomorrow, have ambulance ready. Remember no circus."

"Wait, between four and seven a.m.?"

"Four and seven in the afternoon, tomorrow."

"In the afternoon, ok."

"Prayers and relief coming soon…please learn to enjoy life. Forgive. God protects the chosen. Shari Faye's important request…rest tonight and tomorrow. Good shall come out of this. Blessings are near. Remember tomorrow, Wednesday, four in the afternoon until seven in the evening. Ambulance ready…no circus."

"No circus, what does that mean?"

"You will receive last-minute instructions where to find us."

At this point, Shari's mother intervened, "Do not kill my daughter, please. I mean please."

"We love and miss y'all. Get good rest tonight, goodbye."

Dawn whispered to her mother, "He's gone, Mama."

This call was traced to a phone booth outside the Fast Fare Store at Jake's Landing on Highway 6 near Lake Murray, which is about nine miles from the Smiths' home. Authorities arrived at the location shortly after 10:00 p.m., and once again the caller had disappeared and no useable evidence was found.

Officers quickly began a manhunt around the area of Lake Murray. Roadblocks were set up on both sides of the Lake Murray Dam, but once again, after playing his cat and mouse game, the kidnapper was gone. The roadblocks were cleared around 11:30 p.m.

Five days after Shari's abduction, Wednesday, June 5, at 11:54 a.m., a call came abruptly into the Smiths' home. Shari's mother answered the phone. "Hello."

"Listen carefully. Take Highway 378 west to traffic circle. Take Prosperity exit, go one and a half miles, turn right at sign. Masonic Lodge #103, go one quarter mile, turn left at white framed building, go to backyard, six feet beyond, we're waiting. God chose us."

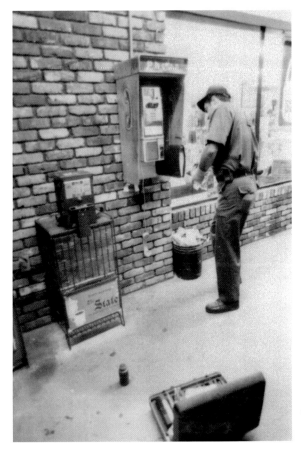

SLED Lieutenant Jim Springs dusting the telephone for prints at Jake's Landing Fast Fare near Lake Murray, South Carolina. *Courtesy of SLED.*

The call was placed through a Camden Highway Switch Station, which is about forty-five miles from Lexington.

The Smiths' first thought was, "Is she alive?"

In a matter of minutes the call came into SLED headquarters requesting the SLED crime scene team to respond to the location. I watched out the window as Lieutenant Jim Springs and Agent Don Grindt started their blue lights and sped out of the parking lot heading to the scene. Shari had been found.

Shari's body was located approximately six feet in the wood line behind the Masonic Lodge #103 at 12:40 p.m. off Highway 391 in Saluda County.

She was found lying on her back still dressed in her baggy white shorts, her yellow-and-black bikini bathing suit bottom and her black-and-white striped blouse. Under the blouse was her yellow tank top. All of the clothing on her body was intact, and she was barefoot. She still had on

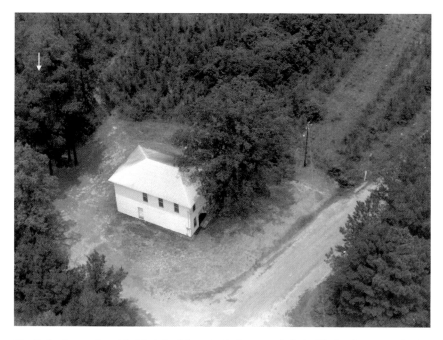

Shari's body was found behind the Masonic Lodge near Saluda Circle. *Courtesy of SLED.*

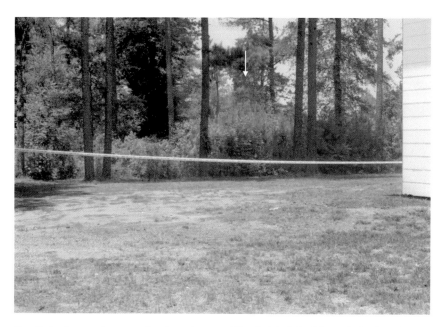

Shari's body was six to ten feet into the wood line behind the Masonic Lodge. *Courtesy of SLED.*

the gold chain necklace that Richard had given to her and one gold stud earring in her left ear. Her right earring was missing. All other jewelry that she had been wearing was missing.

SLED Captain Leon Gasque returned to the Smiths' home to deliver the news. The Smiths were waiting, wondering, hoping and praying. They heard the car drive up and watched Captain Gasque walk slowly to the door. As he opened the door, the look on his face told them that the news would not be what they had hoped and prayed for the past five days.

He choked up as he told them that they had found Shari's body behind the Masonic Lodge in Saluda County. They asked, "Are you sure it's Shari?" He sadly replied, "Yes, it's Shari."

Lexington County and SLED crime scene investigators processed the crime scene. Still photos and video were taken of the scene and the body. The area was thoroughly searched for evidence with no results.

Forensic Pathologist Dr. Joel Sexton, with Newberry County Memorial Hospital, arrived at the scene and was briefed on the case. He read a copy of Shari's letter to her family. He listened to the tape recordings of the calls to the Smith family. His preliminary examination of the scene and body indicated that Shari's body had most probably been removed from a vehicle in the backyard of the lodge and dragged to the area where she was found because there were small saplings and bushes bent over and lying down. Because of the extreme one-hundred-degree temperature, decomposition and insect infestation was present. It appeared that Miss Smith had been dead for at least two days, most probably since Saturday, the day after she was abducted.

Around 6:00 p.m., the body was transported to Newberry Memorial Hospital, Newberry, South Carolina, for autopsy. Saluda County Coroner Bruce Horne assisted Dr. Sexton with the autopsy of the body later that night. The body was positively confirmed to be Sharon Faye Smith by the comparison of Miss Smith's dental records with the decedent's teeth.

During the autopsy, Dr. Sexton collected blood and swabs from various parts of the body, including the vagina and anus. Samples of hair from the pubic and head regions and some tissue were also collected. These were known samples from Shari that could later be used to compare to unknown samples for evidentiary value.

In the case summary of Sharon Faye Smith, Dr. Sexton presented the following:

The cause of death could not be determined with exact medical certainty because of a number of variables: (1) the fact that the decedent was found in an extremely hot area where she had been for at least three or four days, which produced decomposition that destroyed much of the evidence needed to determine the cause of death and a more precise time of death, (2) the decedent had a medical condition which would have led to death in one or two days if she was unable to drink sufficient fluids or take medication, and (3) the autopsy findings of asphyxia are the more general type that can be produced by other conditions. The findings present at the autopsy would fit with a number of causes of death. The two most likely causes are extreme dehydration with associated electrolyte imbalance causing cardiac arrest and asphyxia due to soft ligature strangulation or smothering. It is, therefore, my opinion, in light of the history of the case and the postmortem and autopsy findings, the cause of death best be left undetermined. As far as the manner of death, since the death occurred during abduction, the manner of death will still be homicide, regardless of whether it is due to depriving the decedent of water or from some type of homicidal asphyxia.

The Masonic Lodge is in Saluda County, about sixteen miles from the Smiths' home, which is in Lexington County. Now there was not only the one big question, "who killed Shari?" but there was also "where was she killed?" Her body was found in Saluda County, but was she killed in Saluda County or was she killed in Lexington County, where her abduction took place, and dumped in Saluda County?

When a single crime involves multiple counties, it becomes very tricky when proceeding with the legal process. But at this point, authorities were concentrating more on who killed Shari. They had to get him before he did it again.

Thursday morning, June 6, 1985, the headlines of the *State* newspaper read, "Police Hunt Sick Killer."

There was no useable evidence found where the body was discovered, so all I had to work with in the photography lab that Thursday morning was the film taken at the scene. There were times when I worked with photos and evidence and I had to fight back the tears. This was one of those times as I processed the film and printed the photographs. I lost the fight. I cried.

I've always thought that the worst thing in the world that could happen to a mother and father is to lose a child. The Smiths had such hope, and

this person had put them on an emotional roller coaster for five days waiting for the phone to ring, then his words of rising hope, only to have them fall back down to hopelessness.

And again that Thursday afternoon at 2:30 p.m., another call, but it wasn't to the Smiths. The murderer called Charlie Keyes, senior investigative reporter with a local Columbia TV station, WIS. The station recorded all incoming calls for news, so there is a record of the call.

"This is concerning Shari Faye Smith. I want to use you as a medium. Can you handle it? Ok. Now listen carefully. I can't live with myself, Charlie, and I need to turn myself in and I'm afraid, and you're a very intelligent person, and I want you to be there with Sheriff Metts and all officers he wants at his home in the morning, and you answer the phone."

"At whose home?"

"At Sheriff Metts's home, hurry now, don't answer any questions unless I ask. You be there and you answer the phone [caller gives Sheriff Metts's phone number]. Verify that when you report tonight on Channel 10 TV at seven, cause I want you to make sure this is not a hoax call. After I finish talking, call Sheriff Metts and you talk to him directly and tell him that he received a letter from Shari…handwritten. It was her 'Will and Last Testament,' and on the top of the page it had 3:10 in the morning and the date 6/1/85, and on the left-hand side it had 'God is love,' and was two pages long. It was a legal yellow pad, and he'll know this is not a hoax. Charlie, please help me. Now are you willing to work with me?"

"Yes."

"Ok. Now, be there and you answer the phone and reconfirm that phone number over the TV tonight and make sure I got it right."

"I don't know if I'll be able to do that. Could you just call me back?"

"No! No! Just on the TV…just say if anyone has any information call Sheriff Metts. That's his home phone number. Can you work it in some way or other like that way?"

"Yeh! I'll see what I can do."

"Ok, now, at seven o'clock, do that, Charlie. You call him now where you'll see that this is not a hoax, and I'm gonna give you an exclusive interview…you only…you be there. Have Shari Faye's priest there from Lexington Baptist, ok."

"Uh-huh."

"Now, Charlie…please…it just went bad. I know her family and her, and well I just made a mistake. It went too far. All I wanted to do was to make love to her. I didn't know she had the rare disease, and it just got

out of hand. I got scared and, I have to do the right thing, Charlie. Now, please work with me, cause I feel like I can trust you, and I've listened to you many times, and that's why I picked you as the medium. Six a.m. tomorrow morning, Charlie. Please work with me."

"Ok. I'll see what I can do. Don't worry."

"Now, soon as you call the sheriff, he'll know that when you tell him that information…that only I will know the real person that is responsible for Shari's death and will know what was in that 'Will and Last Testament.'"

"Ok."

"And also, in parentheses it has 'casket closed' as to her request also. You personally tell the family for me that. Please forgive me. God forgives me, and takes care of me. I need the help bad, and I want to do the right thing and tell them to please honor Shari Faye's request, casket closed. Plus take her hands and fold them on her stomach as she's praying. You understand that?"

"Uh-huh."

"Ok. Charlie, I'll be listening for seven o'clock, and if I don't hear the number…"

"Well, I can't read the number, everybody will realize what we're doing here."

"Well, just tell 'em, James R. Metts."

"Ok. I'll see what I can do, and if not call me back."

"Ok, but please I can hear…it's being taped and traced. [sigh] Take me alive, Charlie, ok?"

"Do what?"

"Take me alive."

"Oh, yes, ok, don't worry…don't worry."

"You be the only reporter, now. I don't want to make a circus out of this."

"Right! I understand."

"I'll give you an exclusive interview from the time I picked Shari up until her death…everything."

"All right, fine."

"Ok."

"Thank you very much."

"Oh! Charlie, God bless us all."

"Do you want…you want to tell me where you are, now?"

"Charlie, I'll listen for the news, be there, and you answer Sheriff Metts's phone in the morning."

"Ok."

"Thank you, Charlie."

"Bye, bye."

At 8:57 p.m. that same evening, the Smith family's phone rang. The operator came on the line. "I have a collect call for Dawn Smith."

"Dawn is not taking any calls. Could I have a name, please?"

"Put Dawn on the line please."

"Dawn can't come to the phone right now. This is her Aunt Beverly."

"Well, may I speak to Mrs. Smith? This is an emergency."

"Well, I'm sorry, she is being sedated and cannot come to the phone. She is asleep."

"Ok, may I speak to Bob Smith?"

"Bob is up at the funeral home. You realize the situation with their daughter? Wait a minute, you asked to speak to Mrs. Smith?"

"Or Dawn, I'd rather speak to Dawn."

"Uh, well, let me see if we can find her."

"Ok, hurry up."

"Ok, they are looking for her right now."

"Thank you. Ok, thank you, operator. I'll speak to anybody that comes to the phone, now."

"This is her Aunt Beverly."

"Collect from Joe Wilson. Will you accept the charge?"

"Yes, we'll accept the charge. This is Shari's Aunt Beverly. I'll be happy to speak to you. Who am I speaking to please?"

"I want to speak to Dawn."

"We're trying to locate her. In the meantime, I'll be happy to speak to you."

"No, thank you. I'll have to go then if I can't talk to her."

"She's coming. Wait one moment, please. She went outside to walk the dog. They are looking for her. Ok, here's Dawn right now."

"Hello."

"Dawn?"

"Yes."

"I'm calling for Shari Faye. Are you aware that I'm turning myself in tomorrow morning?"

"No."

"Well, have you talked to Sheriff Metts or Charlie Keyes?"

"Uh, no."

"Well, talk to them and listen carefully. I have to tell you this, Shari asked me to uh, turn myself in on the fifth day after they found her."

"Wait, I'm trying to write this down."

"Don't write it down. I, uh, got to get myself straight with God and uh, turn myself completely over to him."

"Ok."

"And uh, Charlie Keyes…you'll know what I'm talking about when you talk to him. He will not be able to get a personal interview from me in the morning. I'm uh, there'll be a letter. It's already been mailed. An exact copy for you and for him and it's with pictures."

"A copy for me?"

"Yes, and him at his home of pictures of Shari Faye from the time I made her stand up to her car and took two pictures and all through the thing, and the letter will describe exactly what happened from the time I picked her up until the time, uh, I called and told y'all where to find her."

"Ok."

"And I'll be doing the same in the morning at 6:00 a.m. and tell the sheriff and Charlie Keyes. I used him as a medium today and talked to him."

"Ok, at 6:00 a.m., what will you be doing in the morning?"

"Well, he'll know."

"He'll know?"

"Ok, and also that uh, uh, that I will be armed, but by the time they find me, I won't be dangerous. Do you understand that?"

"You will be armed?"

"But by the time they find me, I won't be dangerous."

"What does that mean?"

"Well, I…Shari Faye said if I couldn't live with myself, and she wouldn't forgive me if I didn't turn myself in or turn myself over to God, so I'm going to have to…this thing got out of hand, and all I wanted to do was make love to Dawn. I've been watching her for a couple of…"

"To who?"

"To…I'm sorry, to Shari. I watched her a couple of weeks and uh, it just got out of hand and Dawn, Dawn, I hope you and your family forgive me for this."

"You're not going to kill yourself, are you?"

"I…I can't live in prison and go to the electric chair. I can't do that. This is the only way I can get myself straight. I'm very sick, and I can't go through…"

"We don't want you to die. We want to help you. Don't kill yourself."

"No, I just uh, you can't take someone's life, and this is the way it's going to have to be. Shari said…"

"But listen to me, ok?"

"Well, listen I have to go."

"No, I've got to tell you something. This is important."

"Well, these calls are being traced."

"But God can forgive you and erase all of that."

"Dawn, I can't…I can't live with myself."

"And we can forgive you, too."

"I can't live in prison for the rest of my life or go to the electric chair."

"Listen, Shari is at peace with God. She's better off than any of us."

"Well, I want to say something to you that she told me."

"Ok."

"Shari…oh, boy. Shari Faye said that uh…she did not cry the entire time, Dawn. She was very strong-willed and she said that uh, she did not want y'all to ruin your lives…and to go on with your lives like the letter said. I've never lied to y'all before, right? Everything I've told you came through, right."

"Yes."

"Ok, so this is going to have to be the way it is, and she said that uh, she wasn't scared…that she knew that she was going to be an angel, and if I took the latter choice that she suggested to me, that she would forgive me, but our God's going to be the major judgment, and she'll probably end up seeing me in heaven, not in hell. And that uh, she requests…now please remember this. Now, she requests that y'all be sure to take her hands and fold them on her stomach like she's praying."

"Ok."

"And that closed casket…"

"Yeah."

"They already made those plans?"

"Yes."

"Ok, and please have Charlie Keyes with Sheriff Metts, and Charlie knows what to do in the morning and have an ambulance and probably before they get there, they might as well have a hearse also and uh, and I'm just going to allow myself enough time to get in the area and get set up. I'm not in the area, now and uh, it'll be six in the morning that I'll call his office and by the time they reach me, I'll be straight with God and uh… Shari said please take the gold necklace that she had on, and she had one earring in her left ear."

"Uh-huh."

"And uh, save those things and treasure them."

"Save them?"

"Yes."

"She doesn't want Richard to have that necklace?"

"Uh, she said something. There was some special jewelry in her room. I forgot what. It might have been the necklace. But uh, yeah, go, go ahead but the rest of her stuff is irrelevant."

"What about her high school ring?"

"Uh, she said everything else would be decided by the family."

"But Shari was not afraid, and she didn't cry or anything?"

"No, she didn't do anything, and uh, can you handle it if I tell you how she died?"

"Yes."

"Ok, now be strong, now."

"Ok."

"She said you were strong. She told me all about the family and everything. We talked and…oh God…and I am a family friend. That's the sad part."

"You are a family friend?"

"Yeah, and that is why I can't face y'all. You…you'll find out in the morning or tomorrow."

"Yes."

"Ok, I tied her up to the bedpost and uh, with electric cord and uh, she didn't struggle, cry or anything. She let me voluntarily…from her chin to her head, ok, I'll go ahead and tell you. I took duct tape and wrapped it all the way around her head and suffocated her, and tell the coroner or get the information out how she died and uh, I was unaware she had this disease. I probably would have never taken her and uh, I shouldn't have took her, anyway. It just got out of hand and uh, I'd asked her out before, and she said she would if she wasn't going with anybody, and uh, she said also that uh…oh yeah, make sure Charlie Keyes…you know him, the reporter on WIS?"

"I can't think of who he is right now."

"Ok, they'll know who he is. He's the one who wears the bow tie on Channel 10. He's the head news fellow on this case for Channel 10. And, oh yeah, I was there Saturday morning for the search."

"You were at the search Saturday morning?"

"Yes, I was…and if…oh God, Dawn. I wish uh, I wish y'all could help me, but it's just too late. Well, I have to go, now, Dawn. I know the…"

"Let me tell you something, ok? God can forgive you, and through God we can forgive you also."

"Well, uh, Dawn…will you forgive me then?"

"Yes."

"Your family? But I'll have to take the other choice that Shari Faye said to me. I just can't live with myself like this. I'm not…"

"I just think you need to think about that a little harder."

"I'm not going to be caged up like a dog. Ok, now, are there any other questions? I've got to go now. Time's running out."

"Uh, when…when you killed Shari, was she at peace? She wasn't afraid or anything?"

"She was not, she was at peace. She knew that God was with her and she was going to become an angel."

"And she wrote that letter to us of her own free will and all that was…"

"She sure did. Everything I've told y'all has been the truth. Hasn't everything come true?"

"Yes, it has. Can…can I ask you one more question?"

"One more and that's it."

"You told us that Shari was kidnapped at gunpoint?"

"Yeah."

"But she knew you?"

"Yeah. At first, see, I pulled up and uh, I'm telling you the truth. I have no reason to lie to y'all. I've always told you the truth, right?"

"Right."

"Ok, and I had her…asked her to stand there and took two instant pictures."

"You asked her to stand where?"

"At the mailbox with her car in the background. These pictures, detailed pictures will be with…with the letter that you receive. Since I'm out of town…probably not 'til Saturday. And Charlie Keyes will get a copy and your family will get a copy, and it's addressed to you unless the mail holds it up."

"So she didn't realize that you were going to kidnap her?"

"That's exactly right. And uh, what else? So tell Sheriff Metts that it's no use in uh…trying to trace these calls to catch me. It's too late now. I won't be taken alive. And also, Dawn, that uh, uh, he can just call off the damn search. It's over now, and I don't want the people out there wasting their time, and everything I've told you is true and this is coming true, also. I just can't live with it. I can't take it anymore. Shari Faye was right. We, I feel like I got close to her and we…she showed me things. She was very…"

"Why are you talking to me instead of mom?"

"She felt like you were strong-willed more than your mother."

"Oh, did you start talking to her?"

"Uh, she said it was your aunt, but it was your mother, correct?"

"Uh, no, that was my aunt that answered the phone."

"Oh, it was? Ok. She said something about your mother being under medication. Shari Faye told me. Remember I told you on the fifth day to let them know where she was so her blessings of the body could be blessed. Right?"

"Why on the fifth day did she want us to find her? Why not…"

"I don't know. She just…she just said that. I don't know. I don't have any idea. I'm telling you exactly how she died, so she died of suffocation. And so…ok anything else?"

"Why did you…why did you do that?"

"She…I gave her a choice…to shoot her or give her a drug overdose or suffocate her."

"Why did you have to kill her?"

"It got out of hand. I got scared because, uh, only God knows, Dawn. I don't know why. God forgive me for this, I hope. And I got to straighten it out or he'll send me to hell, and I'll be there the rest of my life, but I'm not going to be in prison and electric chair."

"But I don't think taking your life is the answer to this."

"I'll think about it. Well, Dawn, I've got to go now. It's been too long and, uh, tell them to just forget about the search. I'll be in the area long enough in the morning for them to, uh, find me, and by the time I call, uh Charlie Keyes will know exactly the set-ups. I hope now, uh, I know why I'm staying on the phone. They are taping this, right?"

"Uh-huh."

"Ok, good, and anything else? Oh, yeah. Let me tell you. The other night they almost caught me. The ignorant son-of-a-guns, I wanted them to catch me. I felt that way at the time, but now…"

"When…when was this?"

"Uh, when I called at 9:45."

"When you were over near Jake's Landing?"

"Yeah, I was at that Fast Fare thing."

"Yeah."

"I pulled out twenty yards in front of two flashing lights."

"What color car did you have?"

"They hit it dead on it, red, and they didn't even…Dawn, I can't get over this. Them ignorant so-and-sos didn't even turn around and follow

me, and I cut right at that blinking light down there to go the back way on Old Cherokee Road. And there was a highway patrolman or somebody in front of me and pulled the car in front of me, and he let me turn right on Old Cherokee Road. Can you believe that?"

"So, you really wanted to be caught?"

"At that time, but it's too late, now."

"What kind of car was it?"

"Oh, well, they came mighty damn close. Dawn, they're not going to catch me, and I can't give you information because I got to make it back in time, and they'll stop me before I get back if I tell you, but they're right, it was a red one, and I almost got caught three or four times."

"Was it a red Jetta?"

"Dawn, that's irrelevant now. If I die now, or if I die at six o'clock in the morning, it's irrelevant. Well, listen, Dawn."

"I really wish you would just think about not killing yourself."

"And Shari told me to tell you, please go back to Carowinds. I know you live in Charlotte, and, uh, I know a lot about family, and uh, go back and start singing and give it your best, and that she knows that she'll be singing like crazy. When she said that, she was smiling."

"She was smiling and she wasn't afraid the whole time?"

"No, never."

"Because she knew that she was going to be with God."

"That's exactly right, the whole time, the whole time. She's so damn strong-willed, and, and…"

"But, I just wish you would think about not killing yourself."

"I will, Dawn."

"Listen, our prayers will be for you."

"I'll call you collect…will be for you, ok. Will you be home tonight?"

"We are home tonight. Listen, our prayers will be with you, ok? God can do anything and he can forgive you for this."

"Yeah, but you know what's going to happen to me, Dawn? I'm going to be fried."

"You don't know that. God can work miracles. You don't know that'll happen to you. God is merciful no matter what we do."

"It's time now, it's time. I got to go now, and I'll just…I'll think about it, but I've got a lot of things on my mind, now. I know you know that, right?"

"Right."

"And, uh, you answer the phone every time it rings tonight."

"Me answer the phone tonight, every time it rings?"

"That's right, and if it's collect, and I'll say, Dawn, like the break of day, you'll know."

"Ok, now if we're asleep, you let it keep ringing, ok?"

"I will, I will. Ok, well, God bless us all."

"Wait, mother wants to say something to you."

"All right, just one thing and then I'm gone."

"Hello."

"Just say one thing and that's it. Dawn will tell you, and you listen to the recordings and there will be a letter you'll receive probably the next day with pictures and detailed information from the time I picked Shari up at the mailbox up 'til tonight and my departure from this earth. Sheriff Metts might as well call it off. It's over. I will not be taken alive. Dawn told me to turn myself in or turn myself over to God, or I'll never live in peace and never be forgiven and go to heaven."

"Well, turn yourself over to God. That's most important."

"I am and this is the only way. I'm not going to spend my life in prison and go to the electric chair. Well, uh, Dawn knows everything and, uh, God bless all of us and I hope..."

"Listen, I want to ask you something."

"This just got out of hand. This got out of hand..."

"All you had to do was let her go."

"I was scared. She, she, was dehydrating so damn bad."

"You could have called me for medicine. I would have met you anywhere."

"Well, that's irrelevant now."

"I mean all you had to do was let her go. Such a beautiful young life..."

"I know that. That's why I have to join her now, hopefully, and uh, Mrs. Smith, please, uh, ok, well, that's it. I got to go."

"Did she know you when you stopped?"

"Yeah, uh, I took two pictures, instamatic of, I made her stand...well, before she knew I was going to kidnap her, I asked her to stand at the mailbox, and you'll see by the picture...her car door. I think there's about eight pictures and Charlie Keyes will be receiving a set and a detailed letter, like I told you, at his house, if this mail doesn't slow it down, which it probably will. If you don't get it tomorrow, you'll get it the next day. You'll get exact copies, the pictures that he gets and, uh, exact letters, too."

"Do you know all of us or just Shari?"

"I know the whole family unfortunately, that's why I can't face you. Ok, well, Mrs. Smith, please, uh, if I decide different, I've already told Dawn what's going to happen. Her answer the phone tonight only, and it will be

collect, and I'm going to allow myself just enough time to get back in the area to set everything up if you don't hear from me tonight. I knew the calls were traced, and they came real close to catching me three or four different times and they are correct, I am in a red vehicle."

"What kind?"

"I'm sorry, I don't want them to catch me before I meet my maker on Judgment Day."

"You think the maker's going to forgive you now?"

"He'll, he'll do that, or I'll be crucified and go to hell."

"That's right."

"Well, I've got a lot to think about and I'm, I'm gone Mrs. Smith, and uh, please, I know this might be selfish, but, uh, you all please, ask a special prayer for me? Your, your daughter said that she was not afraid, and she was strong-willed. She, uh, knew that she was going to heaven, was going to be an angel, and like I told Dawn, she was going to be singing like crazy and when she said that she was smiling."

"Did you tell her you were going to kill her?"

"Yes, I did and I gave her the choice, like, it's on the recording. I asked her if she wanted it to be drug overdose, shot or, uh, uh, suffocated, and she picked suffocation."

"My God, how could you?"

"Well, forgive us, God."

"Not us, you."

"God only knows why this happened. I don't know. It just got out of hand."

"I thought you were considerate and loving and a kind person."

"Goodbye, Mrs. Smith."

This call was traced to a truck stop at the intersection of Interstate 77 and Highway 200 in Great Falls, South Carolina. This is about halfway between Columbia and Charlotte, North Carolina, and about fifty miles from the Smiths' home. Once again the caller had vanished, and nothing of evidential value was found.

The evening of the following day, Friday, June 7, was Shari's visitation service at the funeral home. The Smith family received friends as law enforcement videotaped everyone who stepped through the doors of the funeral home. The killer got his wish that night: Shari's casket was closed.

During and after the visitation, storms were tearing across the state of South Carolina, and the National Weather Service issued a tornado warning for Lexington and surrounding counties. Most probably the weather was the last thing on anyone's mind.

At 11:00 a.m. on Saturday morning, June 8, the Lexington First Baptist Church was filled. Law enforcement officers were there and videotaped the funeral and graveside services.

Officials believed that the man who abducted and murdered Shari might attend her funeral. They stood ready for anything out of the ordinary. At one point, someone yelled out from among the hundreds of graveside mourners, "I'm sorry, I'm sorry. Whoever is responsible for this, I think you're here. I love you and will not hurt you. Come forward right now." The Smith family was quickly rushed away, and within seconds the man responsible for the commotion was surrounded by officers. Officers hoped this might be the break they were hoping for, but after extensive questioning for about two hours, the man turned out to be just another concerned citizen who believed he could talk Shari's killer into giving himself up.

As they hit another dead end, authorities assured the public that they were working around the clock on what was now labeled the most intensive manhunt in the history of South Carolina.

The Smiths' phone rang at 2:21 p.m. that afternoon when they arrived home from Shari's funeral. Again it was collect. Dawn answered the phone, and the operator came on the line. "I have a collect call for Dawn Smith from Shari, will you pay for the call?"

"From who?

"Shari."

"Yes."

Operator tells the caller, "Go ahead, please."

"Is this Dawn Smith, like the break of day?"

"Yes, it is."

"Ok, you know this is not a hoax call, correct?"

"Yes."

"Ok, did I catch you off guard?"

"Well, yeah, because they said it was from Shari."

"No, I said concerning Shari. Everybody's screwed up here. Excuse my French. Ok, listen carefully."

"Ok."

"Uh, Dawn, I'm real afraid, now and everything and…"

"You're what?"

"Real afraid, and I have to, uh, make a decision. I'm going to stay in this area until God gives me the strength to decide which way…and I did go to the funeral today."

"You did."

"Yes, and uh, that ignorant policeman…the fellow even directed me into a parking space. Blue uniform…outside, and they were taking license plate numbers down and stuff. Please tell Sheriff Metts I'm not jerking anybody around, I'm not playing games, this is reality and I'm not an idiot. When he finds my background, he'll see I'm a highly intelligent person."

"Uh-huh."

"Ok, and I want to fill in some gaps here because now and next Saturday, the anniversary date of Shari Faye."

"Yeah."

"I'm going to do one way or the other, or if God gives me strength before then, ever when, and I'll call you."

"Between now and next Saturday?"

"Yes."

"I think you need to make a decision before then."

"All right, and uh, I could tell her casket was closed, but did y'all honor Shari's request for folding her hands?"

"Yes, yes we did, of course."

"Ok, she'll, she'll like that. That'll please her. Ok, and uh, tell Sheriff Metts and the FBI, damn, that's like the fear of God in you for sure. They treat this like Bonnie and Clyde. They go out and gun you down, and if I decide, if God gives me the strength to just surrender like that, I'll call you, like I said. When I see them drive up, I'll see Charlie Keyes and Sheriff Metts get out of the car, they'll recognize me. I'll approach them, and I'll put my hands straight up in the air and turn my back to them, and they can approach me without shooting me and stuff, all right? I delivered her to Saluda County, I told you exactly how she died and so forth, and when I took the duct tape off of her, it took a lot of hair with it and so, that'll help 'em out. The examiner said they were having problems telling how she died. And, uh…well, hold on a minute now and let's see…"

"Where's the duct tape?"

"Huh?"

"Where's the duct tape?"

"Only God knows, I don't…ok, ok, now listen. Did you receive the thing and the pictures in the mail?"

"They're coming?"

"Unless the FBI intercepts them. It's written to you. I got Shari Faye to address three or four different things, and it's written to you in her handwriting."

"What is written to me?"

"It's addressed to you. Ok, and now, she, she gave me your address in Charlotte, and there's one picture she wanted me to send to you, and you'll get that in about a week or so, to your Charlotte address and it's…this little note is for your eyes only in her handwriting and she said, Richard, don't tell him this, it'll break his heart. She was getting ready to break up with him, because he was over jealous and that, uh, she couldn't go anywhere and talk to any fellows without him arguing with her, and every time he'd come down to the flea market where she worked in the concession stand, he'd get mad because she couldn't talk to him and working. He worked at the Casual Corner at the Point, I believe."

"Uh-huh."

"Ok, and let's see, and there's only me involved on this, ok, and we talked from, uh, actually she wrote the 'Last Will and Testament,' 3:12 a.m. She kind of joked and said they won't mind if I round it off to 3:10. So, from about two o'clock in the morning from the time she actually knew until she died at 4:58, we talked a lot and everything, and she picked the time. She said she was ready to depart. God was ready to accept her as an angel."

"So, the whole time, you told her that she was going to die, right?"

"Yeah, ok…and uh, all those times and stuff I gave you before were correct and accurate, ok. When are you going to go back to Charlotte and get the letter? Whenever I get strength, and God shows me which way, I'll mail it like a couple of hours before."

"Ok, where is Shari's high school ring?"

"Uh, Shari's high school ring was not with her."

"It was not with her?"

"No, not unless it was in her car or her pocketbook."

"She always wears that ring, and if it was, please, you know…"

"I'm telling you the truth."

"The family would really like to have it."

"I'm returning everything. I mean I don't have anything of Shari's. I don't have that. If I had it, I'd mail it to you. I'm not lying to you. Ok, you said that, uh…Listen, wait, hold on a minute, I'm not finished, now. We talked about it so much. I made clip notes afterward. Uh, she said to tell Robert Jr. That's the brother, right?"

"Yeah."

"Ok, tell him to grow up and meet his goals and pick a sport out, and he's a big boy, and uh, excel in it."

"Uh-huh."

"Ok, and then the last thing, oh yeah, for respect of your family, Shari Faye always told me to respect the family, and I didn't mail Charlie Keyes a set of pictures and letters. I want your family only. So when you find me, uh, if God gives me the strength, ever which way he decides, it'll be in a plastic bag on my body, on my person, because if the media got a hold of this they'll have a field day. I chose Charlie Keyes as a medium because I thought he was very levelheaded, and he wouldn't let it get out of hand, and I can trust him, 'cause I kind of know him. Ok, uh, the last thing she said is…a song, she wouldn't tell me, she said, well, I have to keep some things secret with you, and she kind of chuckled. She said that Dawn would know on her birthday, which is what, June 12, or something?"

"On Shari's birthday?"

"Yeah, June or August…she told me…"

"It's June."

"Ok, well, ever when it is. I think she said the twelfth or something, but anyway, uh, she said to pick her favorite song, and just you and the family, uh, you sing it and, uh, she'll be listening, and uh, put some real feelings behind it. Ok, and let's see, she, dang, let's see, let me go back through it. Ok, I was at the search Saturday morning and also Tuesday morning. I showed up when they called the volunteers off."

"You were there?"

"Yeah."

"You were there Tuesday morning also?"

"Yeah."

"Were you there last night?"

"No, but I was there for the funeral this morning. And, uh, they took license, still, I'm not a damn idiot. I never had any problems before, and it's just something that got out of hand and that's all."

"Can I ask you something?"

"Ok, now ask questions, but hurry."

"Uh, I know that you keep telling me that you're telling me the truth, but, uh, you did tell me that you would give yourself up at six o'clock this morning. Well, what happened?"

"I didn't have the strength."

"What?"

"I didn't have the strength. I was scared. I'm scared as hell. I can't even hardly read my handwriting."

"Well, listen."

"Hurry, I've got to go."

"No matter what you've done, you know that Christ died for you so that you could be forgiven, and if you would give yourself up..."

"Do you know what would happen, Dawn? Do you realize Sheriff Metts...Sheriff Metts would give me help for a couple of months, and then they'd find out I'm sane, and then I'd get tried and sent to the electric chair...put in prison for the rest of my life. I'm not going to, uh...go to the electric chair."

"You keep telling us to forgive you...you don't realize what you've put us through. How could you think about what would happen to yourself?"

"Ok, any other questions? I've filled in all the holes and everything. If the only reason you wouldn't get that letter today or probably Monday, is that the FBI intercepted it."

"Can you tell me where her ring is? You really don't know where it is?"

"No, I don't, Dawn. I would send it to you if I did. I have no reason. I'm not asking for money, materialistic things. I don't have any reason for...she was not wearing a high school ring when she got in the car, so maybe she left it at the pool party she came from."

"Uh, can you tell me? Where did Shari die?"

"I told you, 4:58 in the morning."

"No, I know the time, *where*?"

"Saturday morning in, uh, Lexington County."

"In Lexington County?"

"Uh-huh."

"Where in Lexington County?"

"Anything else you want to ask me?"

"That's what I'm asking you, *where*?"

"Uh, anything else?"

"You won't answer that for me?"

"No."

"You said anything I'd ask, you'd tell me."

"Ok, I'll tell you. Uh, number one. I don't know exactly the location. I don't know the name of the highway, 391 or something like that, but right next to the Saluda County line. That's all I can tell you. Ok, anything else? I'm getting ready to go. At 4:58 in the morning, set your alarm wherever you are, and I'll call you. Can you hear me?"

"Yes, this morning?"

"No, next Saturday, on the anniversary date. Ok, I'll call you and tell you the exact location, just like I did Shari Faye's."

"I can't believe this because you've never been telling me the truth."

"Ok, I have. You believe everything because it is the truth. You go back and you go over everything."

"I just feel that the best thing for you to do is give…"

"Well, Dawn, God bless us all."

The phone went silent, and the caller hung up.

Dawn had really worked on him that time. She turned the control thing around on him, trying to find out all she could to pull this monster out of hiding. She had just buried her sister, but still she had to listen to all of this and relive it all over again. The change in her voice showed that she had had quite enough of his lies and details, especially him telling her how he and Shari started sharing personal secrets. She knew Shari would never even speak to this kind of person, much less share secrets with him.

This call was traced out of state to a Racetrack Service Station in Augusta, Georgia, which is about sixty miles from the Smiths' home. Once again, when officers arrived at the location, no one was there and no evidence was found.

Not only did this person have the Smith family hostage, but also the entire community and surrounding areas. The old familiar statement was a topic of conversation everywhere: "You read about it in the newspapers. It happens in big cities, not in a small community like Lexington."

I love the freedom of my morning runs. I believe that if something happens to me when I'm running, then I would leave this world doing what I love. But with this cloud of fear everywhere, it certainly gave me second thoughts about my solitary runs.

In the midst of all this, I took a break and went shopping for a pop-up camper. It was refreshing to get away from the real world and escape into my recreational world. I took an entire day, and my friend Sheila and I went to check out several campers. One was located at an address off Highway 378, near Lake Murray. We checked that one out and stopped at a phone booth near Lakeside Marina on Highway 378 to call about another one. I could see someone in the phone booth, but he wasn't talking on the phone. The receiver was still on the hook. We rolled our windows down. The temperature was still in the nineties, but it was a beautiful, sunny day. The man sort of leaned out the phone booth with one arm stretched and his hand holding onto the door. He looked straight at us with a stark look in his eyes. He cocked his head, made some strange gestures and moved back into the phone booth. He still did not pick up the receiver. He leaned back out of the phone booth and stared at us

again, and this time gave us a silly, bug-eating grin. I turned to Sheila and said, "He's a strange bird, huh?" Then he stepped completely out of the booth, walked down toward the water and the marina and out of sight.

Working with descriptions and faces every day at SLED, I watch people. I took mental pictures as well as physical pictures. He was about five foot seven with a stocky build and a slight beer gut. He had a round face, short trimmed beard and mustache and short brown receding hair.

It was such a feel-good sunny day, and my mind was on finding a camper. I made the call, and we were off.

Six days passed. The caller was silent. Had he carried out his threat to kill himself? Authorities thought not. They felt that he was getting too much pleasure out of what he was doing. In the silence, the unknown became the extreme fear. Authorities knew if this person killed once, he could certainly kill again.

Still not knowing which county Shari was killed in, Saluda and Lexington County Sheriff Departments declared a legal state of emergency to document that there was no county line in this case. It became a joint effort between the two counties. Investigators still had only sketchy information about the suspect, so the FBI offered technical assistance.

John Douglas, an FBI profiler, was called in to provide a possible profile on this person. After scrutinizing every detail of Shari's abduction, Douglas generated a twenty-two-point profile. He pointed the abductor as a white male, late twenties to early thirties, single, blue-collar day laborer with above average intelligence, probably worked in electrical contracting because the phone calls appeared to be electronically distorted, prior criminal record, lived locally and blended into society. The tone and content of his phone calls indicated him to be asocial obsessive compulsive. If the stress of everyday life became too great, he would break down and would then need to compensate for his own inadequacies. He had no remorse through violent actions. He was the type of guy that feels like one grain of sand on a beach, where there are billions and billions of grains of sand. He feels like nothing. He feels like a nobody. He is probably overweight and unattractive, with low self-esteem. The only way he can become somebody is to go after a victim with whom he would have no chance to ever come in contact, someone like Shari. This makes him think that he can become powerful and in charge.

To further the efforts to generate leads, *Crime Stoppers* TV program did a television reenactment of Shari's disappearance and death. *Crime Stoppers* is a partnership of the community, media and law enforcement designed

to combat crime. Anyone can call to give tips or information of a crime or persons involved and remain anonymous. An article on the *Crime Stoppers* program was also run in the *State* newspaper.

Sheriff Metts advised the public, "Somebody somewhere has seen him. Somebody somewhere knows him. We've got to find this person before he kills again."

The first showing of the reenactment aired on Friday, June 14. On that same day, at 4:07 p.m., about twenty-five miles from the Smiths' home and exactly two weeks almost to the hour that Shari Faye was abducted, it happened again.

It was a bright, sunny day, and the weather was still unseasonably hot in the Midlands. Nine-year-old blond-haired, blue-eyed Debra May Helmick and her six-year-old sister, Becky, and three-year-old brother, Woody, were running and laughing as they played in the yard in front of the family's mobile home in the Shiloh Mobile Home Park. There were thirteen trailers in the park with only one entrance. It was located on Old Percival Road in Richland County.

Debra May's mother, whose name was also Debra, was getting a ride to work with her friend, Vickie, who also lived in the mobile home park. Mrs. Helmick worked at Ray Lever's Bar-B-Q Restaurant. The children were going to ride with them, and then they would stay with Vickie until their father got home from work.

As Mrs. Helmick was coming out of the trailer, Mr. Helmick arrived home, so Debra May and Woody stayed at home with him. Becky went with her mother.

Johnny Flake, a friend who worked with Mr. Helmick, had given him a ride home. Johnny went inside the trailer and sat on the couch in the front room, while Mr. Helmick went to the rear bedroom of the trailer to change clothes. Debra May and Woody stayed outside in front of the trailer and continued playing.

The temperature in Columbia was still in the nineties. The air conditioner, which was located in the front room window of the trailer, was running on high.

At about 4:00 p.m. that afternoon, a silver-gray car with red racing stripes turned into the park entrance and drove down the short driveway that dead ended in a wooded area between the trailers. The driver paused for a moment, turned the car around and slowly started his way back up toward the entrance of the trailer park. He stopped the car in front of the Helmicks' trailer, opened his car door and left the engine running.

Shiloh Mobile Home Park. The Helmicks' trailer is first on the right. The driveway dead-ended in a wooded area. *Courtesy of SLED.*

The front of the Helmicks' trailer, where Debra May was abducted. Ricky Morgan's trailer is in the mid-background. *Courtesy of SLED.*

Woody hid behind the bush near the door of the Helmicks' trailer after Debra May was taken. *Courtesy of SLED.*

Four trailers down and across from the Helmicks', Ricky Morgan was in his kitchen mixing up a pitcher of orange juice. Ricky did not have his air conditioner on, and instead had his windows open. He looked out the kitchen window and yelled, "Oh, my God!" He saw a white male get out of the driver's side of a car parked in front of the Helmicks' trailer, grab Debra May around her waist from the back and then take off running to his car. The car sped off as Ricky ran out of his trailer toward the Helmicks' trailer.

At the same time, Mr. Helmick heard one of the children yelling but thought they were just playing until his friend, Johnny, said, "One of your kids is yelling and hollering out there." Mr. Helmick ran to the front door of the trailer and jumped outside. He saw Woody, scared and shaking, crawling around under a bush on the side of the trailer. Woody was yelling something to him, but he couldn't understand what he was trying to tell him.

That's when Mr. Helmick heard Ricky yelling to him, "Did you see that man take your daughter?"

Overcome with shock, Mr. Helmick ran around the trailer looking for Debra May. Not seeing her, he ran out to the road. Not seeing her anywhere he rushed back to Johnny. They jumped in his car and quickly drove down to the intersection of Old Percival Road and Alpine Road,

where Mr. Helmick jumped out and stopped cars, asking if they had seen a speeding car heading in any direction. He then saw a Richland County Sheriff's car coming toward him. He started running toward the deputy's car, flagged him down and yelling, "Someone has taken my daughter!"

The car was nowhere in sight. The abductor and Debra May had vanished.

The officer radioed for assistance. Additional officers arrived and immediately initiated a ground search. A helicopter and airplane began an air search.

Authorities' thoughts turned instantly to the abduction of Shari Faye, wondering if this might be the act of the same person. If it was, they knew what he was capable of doing. Although they had no clue at this point if there might be a connection, there had been another abduction and another blond-haired girl was missing. Was it just a coincidence that it happened exactly two weeks and within an hour of the time that Shari was abducted?

A few miles away, Debra May's mother went to the back room of the Bar-B-Q Hut to get a can of pork and beans. She heard the telephone ringing. Her head rose, and a strange feeling came over her. She didn't really think anything about it, just shrugged it off and opened the can of beans. As she walked back in the kitchen area, her boss walked up to her and said, "Get your pocketbook. Your mother-in-law is coming to pick you up." Her first thought was that her neighbor had been in a wreck on the way back to the trailer park and her daughter, Becky, had been hurt.

As her mother-in-law drove up Mrs. Helmick ran to the car and shouted, "What's going on?"

Hysterically, her mother-in-law said, "Debra May has been kidnapped."

"Oh, that's bull," Mrs. Helmick said. She knew her husband, Sherwood, did not want her to work, and he would do anything to get her away from work, but after only seconds of listening to her mother-in-law, she knew this was real. Neighbors had already gathered around the Helmick trailer with support and prayers for Debra May when Mrs. Helmick arrived back at the trailer park.

Mrs. Helmick flashed back to that afternoon, thinking how usually the kids rode to work with her and Vickie because Sherwood was not yet home when she left for work. Today he had come home early, and Debra May had said she would stay and watch Woody. Becky had wanted to ride with her mother. Debra May was waving goodbye, had Woody propped up on her hip and her pocketbook on her shoulder. She probably had that pocketbook with her because she had names of kids

The State

Columbia, South Carolina — Saturday, June 15, 1985

South Carolina's
Largest Newspaper
94th Year — No. 166
3 Sections — 46 Pages

Child kidnapped

Man grabs 10-year-old, speeds off in car

By SCOTT JOHNSON
and CHARLES POPE
State Staff Writers

A "shy and cautious" 10-year-old girl playing in her yard off Old Percival Road was abducted Friday afternoon by a man who drove away with her in a silver-colored car.

Richland County Sheriff Frank Powell said Debra May Helmick, of Shiloh Trailer Park, was abducted at 4:07 p.m. from the yard alongside her family's mobile home. The kidnapper was described as a white man in his mid 20s, weighing about 200 pounds and wearing only short pants.

The sheriff said the girl was playing with her 3-year-old brother in a small patch of grass in front of the mobile home, about 10 feet from the road. The incident was witnessed by a man who lives in a trailer several doors away.

"All I know is I heard her screaming about 4:10," said the witness' wife, who was with her husband when the child was abducted. "He was in the kitchen getting something to drink when he said, 'Oh my God' and ran out the door. But there wasn't anything he could do, there wasn't any time. He just snatched her right out

of the front yard."

The woman said her husband saw a silver Monte Carlo drive to the end of the mobile home park's short driveway, pause and turn around.

Then, as it was leaving, the car stopped in front of the Helmicks' mobile home and the man abducted the child.

"Her father was right inside," Powell said. "Someone who saw it ran up and banged on the door. The father did not even know his daughter had

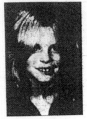

Debra May Helmick

See Abduct, 17-A

Front-page headlines, Saturday, June 15, 1985. *Courtesy of the* State.

Debra May Helmick. *Courtesy of Debra (Helmick) Johnson.*

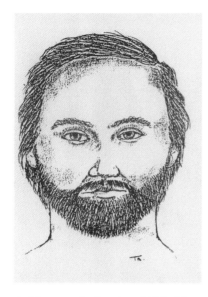

Artist composite drawing of Helmick suspect. *Courtesy of SLED.*

at school in it. "Oh, my God," Mrs. Helmick thought, "If Debra May and Woody had just gotten in the car and ridden to work with me, Debra May would still be here with me."

Investigators immediately began working with Ricky Morgan, the only witness to the abduction. He described the suspect as a white male, thirty to thirty-five years old, five foot nine, 215 pounds with sort of a beer belly, closely cropped brown beard and mustache and brown receding hair.

He told the investigators, "The man was wearing white short pants and a light-colored sleeveless shirt and he had something white in his hand that looked like a bag. When he approached the children he leaned over like he was talking to them. That's when he grabbed Debra May, and she started kicking and screaming. I saw her feet hitting the top of the car as he threw her across the seat, and then she stopped kicking."

Ricky thought the car to be a 1982 or 1983 silver-gray Grand Prix or Monte Carlo with red racing stripes. He focused in as well as he could on the license plate, recognizing that it was a South Carolina plate and remembering the first letter on the plate was "D."

Officers also talked to Woody. Still shaking and scared, he kept saying, "The bad man said he was coming back to get me."

The Helmick family had moved to South Carolina from Canton, Ohio, in March 1981, when Debra May was five and a half years old and Becky was twenty-one months. Mrs. Helmick was pregnant with Woody. They lived with Mr. Helmick's mother in Blythewood, South Carolina, until they moved into the Shiloh Mobile Home Park in May 1985. They had only lived in the trailer park two weeks before their nightmare began.

Debra May's abduction thickened the cloud of fear over Lexington and Richland Counties. It was summertime. School was out, but the normal sights and sounds of children playing outside were missing. Everywhere the conversation was almost always on Debra May and Shari Faye.

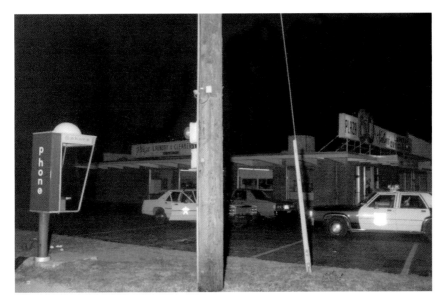

The call to the Smiths' residence giving the location of Debra May's body was placed from the phone booth at Palmetto Plaza in Sumter, South Carolina. *Courtesy of SLED.*

Ricky Morgan assisted authorities by working with an artist to prepare a facial composite of the abductor. The composite was released to the media and calls flowed in from concerned citizens who believed they knew the man. All tips proved futile.

Many unfounded tips and rumors had spread since Debra May's kidnapping. Richland County Sheriff Frank Powell announced that he would not release any more information on the kidnapping until specific progress was made.

And this was the calm before yet another storm.

Eight days after Debra May's abduction and thirty miles away, the Smith family's phone rang. It was 12:17 a.m., Saturday, June 22. It had been fourteen days since Shari's abductor and murderer had called. Dawn answered the phone. The operator came on the line. "I have a collect call from Shari Faye Smith."

"Yes, I'll take the call."

"Thank you, Dawn. You know this isn't a hoax, correct? Uh, did you find Shari Faye's ring?"

"Uh, no I didn't."

"Ok, I don't know where it is ok? Uh, you know, uh, God wants you to join Shari Faye. It's just a matter of time…this month…next month…this

year…next year. You can't be protected all the time…and you know… uh…have you heard about Debra Mae Hamrick [*sic*]?"

"Uh, no."

"The ten-year-old…H-E-L-M-I-C-K."

"Richland County?"

"Yeah, uh-huh, ok, now listen carefully…Go 1 north…well…Bill's Grill. Go three and a half miles through Gilbert. Turn right. Last dirt road before you come to stop sign at Two Notch Road. Go through chain and no trespassing sign. Go fifty yards and to the left. Go ten yards. Debra May is waiting. God forgive us all."

"Hey! Listen."

"What?"

"Uh, just out of curiosity, how old are you?"

"Dawn E., your time is near. God forgive us and protect us all. Goodnight for now, Dawn E. Smith."

"Wait a second here, what happened to the pictures you said you were gonna send me?"

"Apparently the FBI must have them."

"No sir, because when they have something we get it, too, you know. Are you gonna send them? I think you are jerking me around because you said they were coming, and they're not here."

"Dawn E. Smith, I must go."

"Listen, you said you were gonna…and you did not give me those photos."

"Goodnight, Dawn, I'll talk to you later."

The caller hung up.

This call was traced to a phone at the Palmetto Plaza Shopping Center in Sumter, South Carolina, approximately fifty miles from the Smith residence, and as all the times before the caller vanished and left nothing behind.

The voice was the same. The words were the same. The explicit detailed directions to Debra May's body were relayed in the same way as were Shari's. Only now he was fixating on Dawn, down to even calling her Dawn E., and threatening her by telling her she would join Shari.

Dawn had had enough of this cold, conniving and brutal murderer, and when she went back at him strong and forcefully, the cowardly chicken hung up.

Colonels Reynolds and Seboe with the Lexington County Sheriff's Office and Lieutenant Hoss Horton with SLED rushed to the location

Aerial view of the location of Debra May's body outside Gilbert, South Carolina. *Courtesy of SLED.*

Debra May's body was found in the wooded area after a chain and a No Trespassing sign. *Courtesy of SLED.*

Dr. Ted Rathbun, forensic physical anthropologist. *Courtesy of SLED.*

the caller had described, and there in a wooded area they found the decomposed body of a child lying in leaves and brush. Once again, time and the ninety-degree weather had taken their toll on the body.

Lexington County investigators and SLED crime scene investigators arrived at the scene. They photographed and processed the scene for any evidence. They collected sections of hair that were scattered around the body. Attached to one clump of hair was a pink barrette.

Although at this time the body was not positively known to be that of Debra May Helmick, authorities were working on the strong possibility that it was. If it was Debra May, authorities would pursue positive connections between the abductions and slayings of Shari and Debra May.

SLED Agent Ken Habben assisted with transporting the body to Lexington County Hospital for autopsy. Pathologist Dr. Erwin Shaw began the autopsy around 10:00 a.m. that Saturday morning. Habben

Baby Debra May Helmick's footprints. *Courtesy of SLED.*

collected the clothing from the body and transported it back to SLED headquarters for further analysis.

Dr. Shaw's report reflected that because the body was so decomposed, a thorough autopsy could not be performed. He did surmise that suffocation was a prime possibility as the cause of death.

At the request of SLED fingerprint examiner Agent David Caldwell, Dr. Shaw obtained tissue from the deceased's fingers and feet to be used for possible fingerprint and footprint comparisons to determine identification.

Because no dental records were available for Debra May, Lexington County Coroner Harry Harmon and Sheriff Metts requested the assistance of Dr. Ted A. Rathbun, a forensic physical anthropologist with the University of South Carolina, to perform a craniofacial superimposition procedure on the skull of the deceased child.

Craniofacial superimposition is a special technique used as a possible means of identification when dental information is not available. An image of the skull of the deceased is compared directly with a photographic portrait of that individual in order to determine the identity of the skull.

Debra May Helmick's fingerprints. *Courtesy of SLED.*

Sunday evening, June 23, engineers with the South Carolina Education Television studios assisted Dr. Rathbun with the procedure. They set up video cameras and monitors. One camera focused on the skull and one camera focused on the facial photograph of Debra May. The images were then superimposed and viewed on a monitor. Dr. Rathbun adjusted the orientation of the skull with precise accuracy to correspond with the position of Debra May's face in the photograph.

In positioning for the superimposition, particular care was given to the match of anatomical features: the point of the chin, the lower nasal border, the incisor (tooth) edges, height and gap of the central and right lateral maxillary incisors (upper teeth) of both the skull and photograph. Zoom lenses attached to the cameras permitted instant adjustment of magnification of each image to a common scale. The teeth in the photograph and the teeth in the skull were an exact match. Also congruent were the openings and bridges of the nose, the size and shape of the eye sockets, distance between the eyes and the shape of the chin and the right jaw line.

Dr. Rathbun summarized his findings: "In my professional opinion, the superimposition of the skull and the photograph is convincing evidence for the identification of the skeletal remains as those of Debra May Helmick within reasonable medical certainty."

Mrs. Helmick provided for Agent Caldwell the right and left inked foot impressions that had been done at the hospital the day of Debra May's birth. Caldwell compared these impressions to the tissue of the feet of the deceased and made a six-point match of the left foot tissue and the inked impression of the left foot of baby Debra May.

Debra May had been fingerprinted at Hocking Tech College when the Helmicks lived in Ohio. Her records were retrieved and sent to Agent Caldwell. Caldwell compared the right thumb tissue from the deceased with the known right thumb impressions of Debra May Helmick. It was a positive match.

On Monday morning, June 24, I processed and printed the photos that had been taken at the body recovery scene that Saturday morning. It was a repeat of when I had worked with Shari's photos. Tears filled my eyes.

Later that day, I photographed the clothing from the body, which were used as another possible means of identification. Investigators spared the Helmicks from having to view the clothes removed from the decomposed body by instead showing them the photographs of the clothing. They positively identified Debra May's white shorts with pinstripes and snaps and her short-sleeved lavender t-shirt. There were two pairs of underpants on the body, one cotton and one silky bikini. Mrs. Helmick said her daughter only wore cotton underwear, so the silky bikini was definitely not Debra May's.

Mr. and Mrs. Helmick were also shown the pink barrette. Debra May's mother said, "Yes, that's Debra May's. Around two o'clock that day, I washed her hair, brushed it and put two pink barrettes in it. That's one of them."

The hair samples found at the crime scene were submitted to SLED chemist Lieutenant Earl Wells. Wells performed a microscopic comparison examination of the hair found at the body location and the known hair samples of Debra May. Results showed the characteristics of the hair found at the scene were consistent with the known hair of Debra May Helmick.

SLED chemist Chip Priester performed analysis on hair samples of the victim for any residue that possibly may have been left in the hair. Two samples conclusively showed adhesive tape residue. Further tests were

performed to determine what types of tape would have left the residue. Results showed that the adhesive residue found in the hair showed a common origin to either duct or masking tape.

That Monday afternoon, the body found in a rural area of Lexington County near Gilbert, South Carolina, was positively identified as nine-year-old Debra May Helmick.

At a news conference that same day, Sheriff James Metts announced, "We now believe the cases of Shari Faye Smith and Debra May Helmick are one and the same."

With the cases now linked, the earlier composite of the suspect from the Smith case, which depicted a cleanshaven, slightly balding white male, was abandoned, with the theory that he had now started growing a beard.

Sheriff Metts issued an urgent warning to the public that everyone should use their utmost extreme caution to protect themselves and their families during these serious times. "There is a killer out there who randomly selects and kills people, and he could kill again."

Mrs. Helmick said, "We watched the news about Shari's abduction and murder on TV, and Debra May would sit on the floor in front of the TV and listen to it and say how pretty Shari was, and how sad it was that she was killed. After the abductions were connected, all we could see on TV was Debra May's picture right there beside Shari's."

Officers were at the Helmicks' trailer twenty-four hours a day in hopes that the killer might call as he had with the Smiths, but no calls came in.

One night Mr. Helmick lost it when he was sitting in front of the TV and Debra May's picture kept flashing up. He picked up the TV and threw it out the door. Officers subdued him with no questions asked. One officer said, "Let's just leave him alone."

At this point, the Smiths had never met the Helmick family, but they felt a deep tragic bond to them. Both families had lost their beautiful daughters to this killer, and he was still out there and quite possibly looking for another prey.

Funeral services for Debra May were scheduled for Tuesday, June 25, but Mrs. Helmick told them not Tuesday, because that was Becky's birthday. So Debra May's services were held on Wednesday evening, June 26. A sheriff's airplane flew overhead, and law enforcement officers were on the ground at the church and cemetery in the event that the killer would be in the crowd.

Family, friends and relatives filled the church. The Smith family also attended the funeral, offering their prayers and strength to the Helmicks.

Left: ESDA examination of the first page of the "Last Will and Testament." *Courtesy of SLED.*

Below: Close-up of the indentations of numbers on the ESDA examination. *Courtesy of SLED.*

"Jesus Loves Me" was sung for Debra May. The minister included in his message, "This is a very difficult time for all of us. We are afraid, angry, sad and broken. When will it end?"

It had been twenty-seven days since Shari's abduction.

It had been thirteen days since Debra May's abduction.

And finally it ended.

An investigative team had concentrated in depth on the indented numbers on the ESDA exam of Shari's "Last Will and Testament." After

using many different combinations of numbers, they came up with a number that turned out to be a Huntsville, Alabama telephone number.

The telephone number was targeted through the FBI as being called from a residence and a business in the Lexington and Saluda County areas.

The residence number was that of Ellis and Sharon Sheppard, who lived in Saluda County, which was fifteen miles from the Smiths. The business number was that of Sharon Sheppard.

Authorities placed a call to the number in Alabama, and the party was asked if they knew anyone in South Carolina. He answered, "Yes, my mother and father live in Saluda County, Ellis and Sharon Sheppard."

Quickly, authorities zoomed in on the Sheppards, and Wednesday evening, June 26, they established contact with the couple. Almost instantly the authorities knew that this happily married couple in their forties were no part of these horrendous crimes.

Asked about the telephone number that they called frequently in Huntsville, Alabama, they replied, "It's our son Joey's number. He's stationed at an army base in Huntsville."

The Sheppards spoke freely and openly, telling the officers, "We travel and are away from home a lot, so when we are away, we have a housesitter who stays at our house. His name is Larry Gene Bell."

The Sheppards were interviewed into the early morning hours of Thursday, June 27. Officers asked them about Larry Gene Bell. They described Bell as a thirty-six-year-old white male, five foot ten, with a sort of flabby belly, ruddy complexion, reddish brown hair, short and close-cropped reddish brown beard and mustache. He weighed approximately 180 pounds, but the couple said he had lost some weight while they were gone the last time.

Mr. Sheppard stated that Bell had started working for him off and on in the early spring of that year, 1985, as an electrician, and that they had worked together earlier that same day.

When they traveled they did not like to leave the house vacant for that long a period of time, so they thought Bell would be an excellent housesitter.

Mrs. Sheppard said they always had a legal pad beside the phone in the kitchen to use for notes. Before they left on their first trip, they wrote down quite a bit of information on the pad for Bell, which included telephone numbers in case he needed to contact them. One of the numbers they had written down was their son Joey's in Huntsville, Alabama.

Our first trip away, we left for an extended vacation after Mother's Day, May 13. Larry took us to the airport, and at that time he had a beard and mustache. We were gone for three weeks and got back home on Monday, June 3. Larry picked us up at the airport. We noticed that his beard was shorter, and Mrs. Sheppard asked, "What did you do with your beard?"

Bell answered, "I'm getting summerized." Then his conversation started on the Shari Smith abduction, and there it stayed.

Bell spent that Monday night at the Sheppards' house, and the conversation kept going back to the Smith abduction. Mr. Sheppard said that Bell asked him, "Do you think the family would want to find the body so that they could make the funeral arrangements?"

Mr. Sheppard replied, "Well since she was kidnapped, hopefully she is still alive." This was not mentioned only once, but several times.

Mrs. Sheppard said that Larry called her Mrs. Sheppard when they first met. Then he started calling her Sharon, and after they returned on June 3, he started calling her Shari. That was the first time that he had called her Shari.

Mr. Sheppard admitted that he and Mrs. Sheppard had become very interested and concerned with the Smith abduction, but not to the point of obsession that Larry had.

The next morning, June 4, Larry went to work with Mr. Sheppard, and that night he stayed with his parents on Shull Island at Lake Murray, which is several miles from the Sheppards' home.

On Wednesday, June 5, around 1:30 p.m., the Sheppards' neighbor came by and told them that Shari's body had been found at the Masonic Lodge near the Saluda traffic circle, which was about three miles from the Sheppards' house.

Larry returned to the Sheppards' home around 2:00 p.m. that Wednesday to drive them to the airport to leave again for the second part of their vacation. When he walked in the door, Mrs. Sheppard asked, "Did you hear the news that the Smith girl's body has been found near the Saluda traffic circle?"

He quickly answered, "No! Too bad."

Mrs. Sheppard said,

On the way to the airport that was all he talked about. It started getting on my nerves because every time we tried to change the subject he would start again; "but what if this, but you know this, and how

about this. The person that did this could have taken the body there, but then again…" And he kept saying over and over, "I feel so bad for the family. I feel so bad for the family."

When we got on the plane, I told Ellis that Larry was driving me crazy. I wanted to knock him over the head…The first time we left for vacation I told Larry to throw away the newspapers so they wouldn't pile up, but this last time, I was so upset and saddened by all of this, and that the girl's body was found so close to our house, I asked him to please save the newspapers. Larry picked us up from the airport when we returned this past Monday, June 24. I noticed he looked much thinner, like he had lost about ten pounds. His appearance wasn't as neat as usual, and he seemed a little spacey. He drove, and I sat in the back seat behind him. I leaned up and patted him and said, "You look tired, are you ok?"

And he said, "Well, no, I'm just not myself."

Ellis jokingly told him, "You need to get back home and eat your mama's cooking."

When he got us home, he packed up all of his things, said he was spending the night with his parents and would be back in the morning to go to work with me. We thought this a little strange, because the first time we came back, he left his things because he knew he was coming back in a few days to take us to the airport and housesit again while we were gone. This time even though he knew we were leaving again on that Friday, he took everything of his from the house, except some postcards and a gift that we sent him. I was anxious to read the newspapers that he had saved for me and was stunned to see he had meticulously cut out and organized all the articles about the kidnappings and murders. They were not just from the Columbia area newspapers, but different areas around the state. Then chills covered my body when I saw the photo of the facial composite from the little girl's abduction and murder. I was shaking as I told my husband, "I don't like the feeling I have. That composite looks sort of like Larry, and his obsession with all of this, and saving the articles. Oh, my God, could he have something to do with this horrible thing?"

Mr. Sheppard continued,

"Gracious, no, not Larry." I didn't want her upset about this, but that thought and my wife's fear did not leave my mind. I went back and looked at the composite. There was definitely a likeness that made me think, and then I remembered that I had told Larry I kept a gun

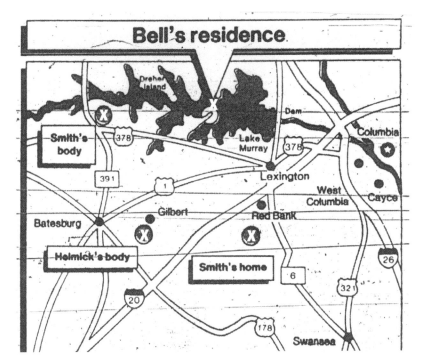

A sketch showing the Bell residence, Smith home and the Smith and Helmick body locations. *Courtesy of the* State.

in the house because of living so far out in the country. So with us going through these weird feelings about all this, I checked on the gun. I couldn't find it, so at eleven o'clock that night I called him at his parents'. I asked him where the gun was. He said it was under the mattress on the side of his bed by the wall. Then I told him I would see him in the morning and hung up. The gun was under the mattress like he said. Sharon had already gone to bed, and I wasn't about to tell her about the gun. The next morning Larry came over and while we were driving to work I sort of eased into him. "That composite in the paper looks a little bit like you, Larry. What you think?"

He spoke as usual, "Well, they did stop me twice in roadblocks they had set up but sent me on through. Other cars were being stopped, too."

I guess I was just trying to make myself feel better because I just couldn't believe that Larry would do something like that.

And then their fear became justified. A copy of the excerpts of the telephone call concerning the Helmick victim was played for the

Sheppards. They both immediately identified the voice as that of their housesitter, Larry Gene Bell.

Mrs. Sheppard broke into tears and cried. Mr. Sheppard gasped, "My God, he threw her body out around Bill's Grill. Larry told me numerous times that Bill's Grill in Gilbert was one of his favorite places to eat. Now, I am mad."

Further information on Larry Gene Bell was developed throughout the evening, and a background investigation showed that over the past ten years, Bell had had many altercations with the law with assaults on women.

In February 1975, he was arrested in Rock Hill, South Carolina, and charged with aggravated assault and battery. He approached a young lady who was in a shopping center parking lot, walked up to her and said, "Come go with me. Let's go to Charlotte and party."

She said, "No," and he pulled a knife on her, pointed it at her stomach and tried to drag her to his green Volkswagen. She fought and screamed, and he gave up and got in his car and left. A lady in the shopping center heard the lady's screams, ran to a phone and called police. He was arrested a short distance from the shopping center. This was Bell's first arrest. He pled guilty in May 1975 and was sentenced to five years in prison and a $1,000 fine. The sentence was suspended upon payment of fine, and he was placed on five years' probation. At that time, Bell was employed by Eastern Airlines in Charlotte, North Carolina, and lived in Rock Hill with his wife and two-year-old son.

In October 1975, while on probation, he approached a woman in Columbia, South Carolina, and told her, "I am armed." He showed her a pistol and tried to force her into his car. They struggled, and she was able to get away. He got in his car and left. He was later arrested for this incident and in June 1976 pleaded guilty to assault and battery of a high and aggravated nature. He was sentenced to five years in prison, including revocation of probation in the Rock Hill case. During this stay in prison, the prison's psychiatrist worked with him, and after serving only two years, he was once again out on parole.

Additional records showed that at one time Bell checked himself into a mental hospital, where he was treated for a personality disorder of a psycho-sexual nature and later hospitalized at least two other times for psychological reasons.

In 1976, after his numerous assaults on women, he was diagnosed to be a danger to women and a psychiatric report revealed, "The chance of him repeating his acts is very high."

Bell was arrested about a mile from his parents' residence (mid-photo) on Shull Island, Lake Murray. *Courtesy of SLED.*

Again, in October 1979, in Charlotte, North Carolina, he was convicted for making obscene phone calls to a ten-year-old girl. The calls started in February 1979 and continued into July 1979. In this case, authorities gave the mother of the girl a recording device for their telephone. They successfully taped his voice and some of the conversations. This led to another arrest and subsequently to another guilty plea. He was given a two-year suspended sentence and placed on five-year probation.

Larry Gene Bell was born October 30, 1949, in Ralph, Alabama. He had three sisters and one brother, and the family moved around a lot when he was young. He attended Eau Claire High School in Columbia, South Carolina, from 1965 to 1967. Later he and his family moved to Mississippi, where he graduated from high school and received training in electrical work.

He returned to Columbia in 1969 when he was twenty and married a sixteen-year-old girl. They had a son. He joined the marines in 1970 and was discharged the same year because of a knee injury. While cleaning his gun in his apartment, he accidentally shot himself in the knee. In 1971, Bell worked as a prison guard at the Department of Corrections in Columbia. That lasted one month.

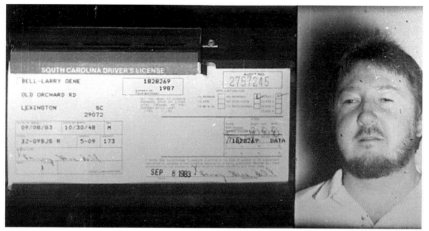

Larry Gene Bell's driver's license. *Courtesy of SLED.*

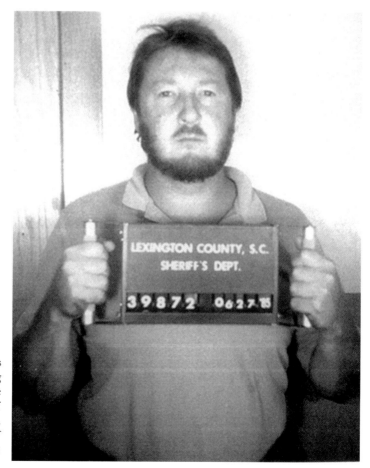

Bell's booking photo the morning of his arrest. *Courtesy of SLED.*

In 1972, he moved his wife and son to Rock Hill, South Carolina. He divorced in 1976 and his former wife and their son moved to another state.

The revelation of this information regarding Larry Gene Bell's past had taken place during an endless night at the Lexington County Sheriff's Department that carried over well into the pre-dawn hours of Thursday, June 27. Given the additional investigative information and after consultation with Lexington County Solicitor Donnie Myers, Magistrate Leroy Stabler issued an arrest warrant for Larry Gene Bell.

Around 2:00 a.m., surveillance and a roadblock were set up about a mile from the driveway at Bell's parents' residence on Shull Island at Lake Murray. As daylight started breaking around 6:15 that morning, Colonels Reynolds and Seboe with the Lexington County Sheriff's Department, Lieutenant Horton with SLED and Lieutenant Wright with the South Carolina Wildlife Department watched and waited for Bell to come out of his driveway on his way to work.

It was the beginning of another sunny and warm day with a forecast of mid-eighty-degree temperatures. The net of fear that had covered the Midlands and South Carolina for twenty-eight days was only minutes from being lifted.

Around 7:30 a.m., Bell's car slowly approached the roadblock. He was driving a late 1970 creamy gray Buick. As he came to a stop, officers approached his car and asked him to identify himself. He answered, "Larry Gene Bell." They asked for his driver's license and instructed him to step out of his car. He offered no resistance and very calmly said, "This is about those two girls. Can I call my mama?"

Larry Gene Bell was arrested and read his rights, escorted to one of the officer's cars, placed in the back seat and transported to the Lexington County Sheriff's Office.

Colonel Reynolds stayed and maintained security of Bell's car. As he reached through the window to turn off the ignition, he observed an opened hawk knife on the passenger side of the front seat.

News of the arrest of a strong suspect was the topic of conversation around SLED headquarters that morning. The Intelligence section obtained a copy of Larry Gene Bell's driver's license and photo. I was requested to make additional copies to assist with the investigation.

I was anxious to see what the person looked like who would do all this. When I looked at his photo my eyes froze on that face. Somewhere, I had seen that face before.

Under advice from the FBI's Behavioral Science Unit, a setting for the interview of the suspect was established in a mobile home behind the sheriff's office. Clad in handcuffs, Bell's eyes focused sharply on the wall of the trailer as he walked in the door. Displayed on the wall were maps with locations and points outlined, photographs of Shari and Debra May smiling, photographs of Shari and Debra May's bodies in the locations where they were found, the composite drawing of a bearded suspect that had run in the paper and stacks of papers and documents. All during the interview his eyes kept finding their way back to all of this.

Lieutenant James "Skeet" Perry with SLED and Lieutenant Al Davis with the Lexington Sheriff's Department were the first to interview Bell. As they walked in the door, Perry asked Bell, "How you doing today?"

Bell chuckled, "Under the present condition, not so good."

Perry began, "The principal issue that we want to talk to you about is what is alleged in that warrant. You have a copy of it. You read it and said you understand it."

The interview between Bell and Perry began.

"Am I being arrested? I'm not gonna have a chance to clear myself before you arrest me? 'Cause that's kind of a flimsy...something about the letter thing being taken out of their house or something or whatever it was. Gosh! That could be a whole bunch of people."

"The arrest was effective when the arrest warrant was served on you. The warrant is nothing but alleging. It does not say you are guilty of what's in the warrant."

"I don't think I ought to be arrested, especially on somebody's say-so that they identified my voice, which that could be a whole lot of people, and especially a legal pad or something like that. Anybody could have taken that, too."

"Gene, you're smart enough to know that the judge did not issue that warrant without sufficient probable cause in his mind and evidence to support it."

"I'm innocent. I surely don't know that I could do that."

"Well, did some other part of you do this? Is there some other person in you that does this?"

"I can say that this Larry Gene Bell didn't do this."

Throughout the interview, the tapes to the Smith family were played for Bell. When Lieutenant Perry played the tape of the last call placed to the Smith residence giving the exact location of Debra May's body, he

said to Bell, "I want you to listen to this one very closely." Bell responded, "That's not the Larry Gene Bell that I know."

"Well, we are going to prove that the letter came from the Sheppards' house…that the top sheet was torn off the yellow legal pad that Mrs. Sheppard left writing on leaving impressions of numbers and letters through the pages…that this was the same pad that Shari wrote her 'Last Will and Testament' letter that was mailed to her family. No one could have had access to that pad but you. Only you had access to the Sheppards' house when they were gone."

"I know for a fact that y'all, like you said…wouldn't have me here without evidence and stuff. I can't confess for somebody else, and I don't want this Larry Gene Bell to be executed for something that is in his mind. He shouldn't have done that to those poor girls."

Lieutenant Davis replied to Bell, "Nobody wants to be electrocuted. Nobody wants to die. That young girl didn't want to die, either. She wanted to graduate. She wanted to go to the beach and have fun with her friends. She wanted to go to church and sing. She can't do that, now. Just like the voice on the tape said, 'She's singing in heaven, now'…And that little girl over yonder, Debra May…younger than Shari, and she had her whole life ahead of her, too. She had a sister and brother. She had a mother and father. That voice on the tape told us exactly where to go. 'Debra May is waiting.' There's no doubt in your mind, listening to that tape that the voice that came out of your body is on that tape?"

"I'm trying to help. By listening to that, you're right. I'm not denying that. All I can say is, it sounds like the Larry Gene Bell sitting here."

Bell stood up and pointed to the photos of Debra May's body and asked, "Can I look at those pictures?" Then he asked for a cup of water and to wash his face. As he was walking to the bathroom, he said again, "This Larry Gene Bell didn't do that."

When he returned he said, "I want to tell you, I just don't know what to say."

After several hours, Lieutenant Perry ended the interview. "I am tired. I've been up for four weeks looking for someone. I think I found him."

After a break, Sheriff Metts walked into the room and formally introduced himself to Bell. He escorted Bell to his office and said, "Get yourself a drink, and I'll set up the tape recorder over here. I want to play some of the tapes for you."

"I've heard all of them."

"Oh, you have. Well, let's just start with this one."

"I'm so nervous and scared. I'm not a criminal."

"Why are you nervous? What's done is done. You can't do anything about that. Talk to me Gene."

"I want to, but it's like a mental block or something."

Sheriff Metts began the tape of the first call to the Smiths. While the tape was playing, Bell kept saying, "I don't believe I did this." At the end of the tape Sheriff Metts looked at Bell and said, "That's you, Gene. I've already told you that we've got the evidence."

Sheriff Metts continued playing the tapes as Bell listened. Bell periodically shook his head and said, "Naw, I can't believe that. That upsets me too much."

"Does it upset you, Gene? You know it's you on these tapes. You know your voice, right? You would have to agree with me that sounds like Gene on these tapes, doesn't it?"

"Yes sir, by the voice thing unless somebody is disguising it or something like that. I haven't listened to myself enough to know [chuckle]. Yeah, put like that, yes sir."

"Well, Gene we both know it's you. Here, let's listen to some more tapes."

Sheriff Metts turned on the tape of the last call to the Smiths that gave the directions to Debra May's body. As it ended, Bell squirmed and paused for a moment, then said, "That didn't sound like me. I just don't believe I'm involved in it."

Sheriff Metts responded, "You are. Gene, this is a terrible thing. Let it out. Hell, break down and cry if you want to. Ask God to forgive you. Get yourself right and help me help others. God help us and protect us all. That's your own terminology, isn't it, Gene? You know for a fact that is you on the tapes."

Bell slumped back and gave a long sigh. "There's no doubt about it. Ever what's in me doing this, or if I did the terrible things, it's just not right. God didn't put me here to take somebody's life. I know and you know what happens to me, now. They're gonna go for the death penalty."

Then he asked Sheriff Metts if he could talk to the Smith family, because if it ended up that he was the murderer after all, he wanted God and them to forgive him.

At a news conference that Thursday morning, Sheriff Metts announced to the anxious public that a suspect was in custody at the Lexington County Sheriff's Office. "Late last night and early this morning, our task force developed crucial information that identified an individual that fits our profile to a T."

Authorities hoped that being face to face with the Smith family might trigger something in Bell and break his shield. So Bell's request to talk to the family was granted.

Around 6:30 p.m. that evening, a patrol car arrived at the Lexington County Sheriff's Office. Dawn and her mother stepped out of the car, and within minutes were only feet away from Larry Gene Bell.

Sheriff Metts, Solicitor Donnie Myers, John Douglas, an FBI profiler and other officers were present in the room where Bell was seated.

As soon as Larry Gene Bell opened his mouth and spoke, Dawn and Mrs. Smith immediately recognized the voice. This was the voice that had invaded their home and terrorized them for weeks, and this was the face that belonged to that voice. He began to speak to Dawn. "Thank y'all for coming. Sheriff Metts said that the evidence is here, but this person sitting here...I could not have done this ungodly thing. Right now, I don't know how to explain it. I know it's touched a lot of people and destroyed a lot of lives. When I click on that reason, I'll let your family know."

"I recognize your voice. I know that it's you. I talked on the phone with you. Do you recognize my voice?"

"I recognize your face from TV and the picture in the paper. It's just the bad side of me that caused all this horrible destruction in people's lives...your sister and that little girl. It's just something in me."

"You honestly can't think back and remember my voice, because you know we talked? Do you remember what you called me on the phone?"

"I guess just Dawn."

"How about middle initial?"

"No. I requested that your family be here. I'm trying to put you to some kind of rest with why. They have the evidence against me. I feel terrible about this if this was directly the result of something bad in me. If God chooses that I end up going to court and being put to death, that's just something I have to do."

"Well, why would you have wanted to hurt me?"

"I don't wanta hurt you. I don't even know you. The person sitting here, Dawn, is not a violent person. I wish I could answer your questions now. If I come up with the answers, and I know I can do that, I'll tell you everything I remember about it. If I was sure this person here was capable of controlling what happened to your sister, I would confess in a minute. I feel guilty about something. When I picked up the paper a couple of days ago, I felt like I was directly or indirectly responsible for

something like that and, Dawn, that's when I felt that somehow I was drawn close to your family...as being a part of your family...if I was responsible for taking away part of your family. It just horrifies me that I can do something like that. Dawn, I hope you believe me. I have soul searched all day, and I'm glad that you came."

"You said in one conversation that you and my sister had become one. Do you think that might have anything to do with that feeling of being a part of our family?"

There was a long pause until Bell spoke again. "I can't answer that now, Dawn. The main reason I want your family here is maybe we can hit on something that would help me explain. I didn't want to talk to you on the phone 'cause I had to sit there for hours today and listen to them darn horrible phone calls...so depressing. It wasn't helping me. It was hurting me."

"But you had listened to them today, and you hear that is you and your voice."

"I would say that 90 percent of it sounded muffled but, Dawn, the other part of it would have to be...unless it's a mighty darn good imitation."

"Talking to me now, can you tell that was me talking on those tapes?"

"Your voice sounds different now than on the tape, but, Dawn, whatever caused this, I truly hope this won't destroy y'all's lives. This is gonna destroy my family, too, but hopefully they'll be strong enough to go on with their lives. There's bad in me, but I can't say the devil put it there, 'cause I say my prayers every night and every morning."

"Well, you have recognized that could be your voice?"

"Oh, yeah! Like I said, 90 percent of it was muffled, but the rest was."

Bell looked at Mrs. Smith and began speaking to her. "Like I told your daughter, Mrs. Smith, if I'm directly responsible for this crime, I do apologize if I've brought tragedy into your lives and tragedy to myself. Your daughter can explain everything else that I've said. I don't know what to say to you. I just can't believe I've done those horrible things."

"Did you know our daughter?"

"No, and I don't know your family. Maybe on down the road I'll have that breaking point that I can come up with the answers for you."

"Nothing you can say or do can bring Shari back."

"No, and if I could honestly say today that I did this, I would tell you right now."

"I know definitely that it is you on the tapes, no question in my mind. I talked to you, and you talked to me, and there definitely couldn't be a mistake there. We just want to know the truth, nothing else."

"When I can come up with the truth, I'll tell y'all all of that."

Mrs. Smith's final words to Bell were, "Even though I sit this close and look at you and know you're the man that called my house, I don't hate you. There is not enough room in my heart for more pain."

Dawn again spoke to Bell. "You said you didn't know me. Maybe I look so much like Shari looked, maybe you can possibly remember something from that."

"If I put that picture of her up beside you, y'all don't look alike...in my personal opinion."

Dawn and Mrs. Smith had listened to Bell's voice for almost an hour. They had had enough.

As they were leaving, Bell asked, "If I remember down the line, can we conference again, and tell you what I know?" Mrs. Smith and Dawn did not answer.

Bell's parting words were, "Thank you very much. God bless us all."

Before leaving the sheriff's department that morning, the Sheppards gave officers consent to search their residence. They arrived back at their home around eight o'clock that Thursday morning. Mrs. Sheppard entered her home. She found the sheet of paper that they had written notes and telephone numbers on for Larry near a picture of her mother and father. She was shaking as she looked at Joey's telephone number on the pad, 205-837-1848, the ten digits that had led authorities to Larry Gene Bell, the person to whom they opened up and entrusted their home. Her house felt so cold and so empty, as she thought, "My God! How could he do those awful things in our home?"

SLED Agents Ken Habben, Lieutenant Jim Springs and Lieutenant Mickey Dawson arrived at the Sheppard home that same morning to proceed with the search of their house.

Lieutenant Dawson took possession of the original sheet from Mrs. Sheppard and labeled it "Sheppard Document." He also requested samples of envelopes, pocket-sized notebooks and pens from the house and from the Sheppards' vehicles.

Agent Habben began his search with the guest bedroom, which was Larry's bedroom. The room appeared very clean and in place and the carpet had been recently vacuumed. Habben collected hairs from the floor along the inner side of the doorway going into the bedroom. He examined the sheets on the bed, and he, as well as Mrs. Sheppard, found them to be freshly washed with no appearance of ever being slept on. Underneath the sheets was a blue fitted mattress sheet, which Mrs.

Aerial view of the Sheppard residence. *Courtesy of SLED.*

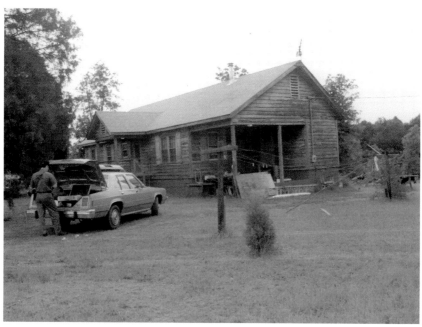

SLED Lieutenant Jim Springs at the Sheppard residence. *Courtesy of SLED.*

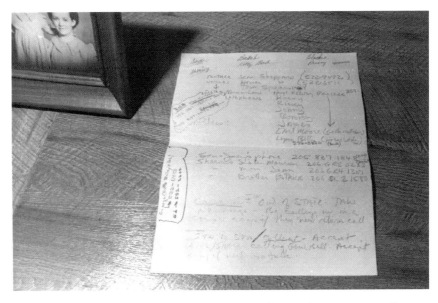

Original sheet of the "Sheppard Document" that the Sheppards wrote notes on for Larry. *Courtesy of SLED.*

SLED Agent Ken Habben collecting hairs from the doorway going into Bell's bedroom at the Sheppard residence. *Courtesy of SLED.*

The blue sheet used as a mattress pad on Bell's bed at the Sheppard residence. *Courtesy of SLED.*

License plate found in the trunk of the car Bell was driving when he was arrested. *Courtesy of SLED.*

Sheppard said she used as a mattress pad. The sheet was dirty, wrinkled and stained. Several red fibers were plainly visible on the sheet.

In the bathroom across the hallway from the guest bedroom, there were four rugs on the floor. All four had hair on them. Habben rolled up each rug so that the hairs and any possible fibers would stay inside and placed them in individual bags. He also collected what appeared to be pubic hairs from around the base of the toilet on the floor.

Duct tape was found in the Sheppards' living room and the pickup truck that Bell was working out of.

During the search, Mrs. Sheppard advised the agents that the first time they came home around June 4, she was walking through her living room and something on the couch caught her attention. "When I took a closer look, I saw a long blond hair sticking up from the couch. I just figured it was his girlfriend's. He had asked permission to bring her to the house while we were gone. I made some silly little remark to myself and plucked it up and threw it in the trash, and didn't think any more about it until now."

Bell gave his consent to search the 1978 Buick Riviera that he was driving when he was arrested. Agent Habben collected and bagged the knife that was still on the front seat. Inside the trunk underneath a neatly folded towel and bedspread was a license tag in a wax paper envelope with the registration card. The registration had the following information: Diane Loveless, Trenholm Road, Columbia, South Carolina. The first letter of the tag was the letter D. The tag was registered to that car, the 1978 Buick Riviera. Diane Loveless was Bell's sister.

At 8:15 p.m. Thursday evening, Sheriff Metts announced the formal arrest and charges against Larry Gene Bell for the kidnapping of Shari Faye Smith.

Bell's parents gave their consent to search their home. The magistrate of Lexington County also issued a search warrant, and on the following day, June 28, Agents Ken Habben and Lieutenant Mickey Dawson went to the Bell residence on Lake Murray.

Dawson searched the residence and found a pen inside a small pocket notebook and envelopes in Larry Gene Bell's bedroom. Inside Bell's top right dresser drawer were several mallard duck stamps.

Habben searched the entire inside of the Bells' residence. All the way in the back of Bell's bedroom closet, underneath numerous items, he found a white plastic bag. Inside the bag was a black starter pistol. This type of pistol can only make noise. It is not capable of firing live ammunition,

although some .22-caliber bullets were found in a plastic sandwich bag along with the pistol. There were also four individual rope-like materials, each approximately four to five feet in length.

Under some of Bell's clothes in his dresser drawer was a bag with several pairs of female silky bikini panties. They ranged in sizes from very small to large.

At the foot of Bell's bed was a newspaper dated Saturday, June 15, 1985, folded so the picture of the recreation of Shari's abduction was in plain sight. On top of it was a pair of tennis shoes and on the shoes were two small spots that resembled blood.

A business card was found in his bedroom that read, "Loveless and Loveless, Inc. Topsoil, Sand, Gravel, and Dirt Cheap, 8405 Old Percival Road, Columbia, South Carolina." This was the business card of Bell's sister and her husband. They ran a landfill topsoil industry out of the sandpit area on Old Percival Road. The sandpit was directly across the road from the Shiloh Trailer Park where the Helmicks lived. It was later learned that Bell worked with them at the sandpit when they needed extra help.

There was another card located near the telephone in the Bells' kitchen. It read, "Bill's Grill, Highway 1, Murray Town, Gilbert, South Carolina."

Duct tape was found inside the residence and in the blue pickup truck that Bell drove, which was parked in the yard. Three rolls of duct tape of various widths were found hanging in the outside storage house.

These cases had become deeply personal to me. I had seen this man before, and it obsessed me knowing that I must have been close enough to him to implant that face in my mind. It wasn't until I saw two full-length photos of Bell in the *State* newspaper that it smacked me right in the face. "My God, this was the strange person that was at the phone booth at Lakeside Marina on Lake Murray the day I was checking out campers."

I was that close to the person who had everyone gripped in all this fear, and I didn't know it. I gathered up my schedules and notes. The only description and facial composite of a suspect the day I was at the phone booth was of Shari's abductor, and he was cleanshaven with a receding hairline. This was during the time that Bell had shaved his beard, what he called being "summerized." When I saw this man at the phone booth at Lakeside Marina it was before Debra May was abducted and he had a beard. The description of a bearded suspect did not surface until after Debra May's abduction.

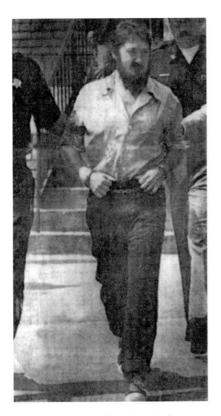 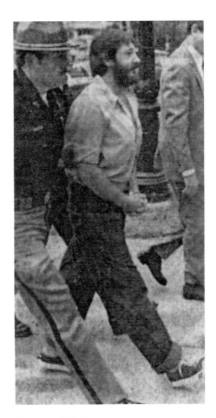

Full-length photos of Bell in the *State* newspaper. *Courtesy of the* State.

SLED Questioned Document Examiner Gaile Heath and I met with the Sheppards later that week for them to view the ESDA product of the "Last Will and Testament" letter. They identified partial indentations of "Mother," "Uncles," "Bob," "tomatoes," "pecans," "beef sticks" and the telephone number as being their entries.

At first when Mrs. Sheppard saw the partial indentation of "tom toes," she gasped, "Oh my gosh, we have a cat named Tommy. Surely he didn't cut off his toes."

Being the curious person that I am, I asked Mrs. Sheppard, "Did you ever suspect Larry of this while it was going on?"

She replied, "I didn't like the feelings I had when I saw the composite and Larry's obsession with all of it so I told Ellis how I felt."

Mr. Sheppard responded, "When we went to bed that night, I thought about women having sixth senses and there just might be something to that. You can bet I will never question hers again."

With the additional information from the Sheppards, Lieutenant Mickey Dawson and Agent Gaile Heath positively determined that the "Sheppard Document" was at one time on top of the sheets on which Shari wrote her "Last Will and Testament."

SLED Chemist Chip Priester attempted to isolate any adhesive residue from the hair that was collected during Shari's autopsy. No adhesive residue of useable value was found, but while cutting, he discovered some small red fibers in the hair.

At the same time, Chemist Bob Carpenter, who specialized in fiber analysis, used a laser light to examine the blue mattress cover collected from Bell's bedroom at the Sheppard house. Some materials fluoresce at the presence of the laser light that are not visible under normal light and shine out like bolts of lightning. Spots that appeared to be body fluids and reddish-tinted fibers glowed extremely brightly under the laser beam. Using a polarized light microscope, Carpenter compared the red fibers from Shari's hair to the red fibers on the mattress cover and concluded that they were exactly the same type of fiber, same size, had the same surface characteristics and could have the same origin or the same source.

SLED Chemist Earl Wells conducted hair comparison tests on the known hair and pubic hair from Shari Smith with the hairs taken out of the Sheppard residence. Using a comparison microscope, viewing the known specimen of Shari on one side of the scope and a questioned or unknown specimen on the other side, Wells began at the root end of the hair in both cases and gradually worked up the shaft of the hair, noting any peculiarities or characteristics that were similar or dissimilar between the known and unknown.

Wells also checked the hairs to determine if they had been forcibly removed. This can actually be seen with the naked eye as well as through a microscope. When hair is forcibly removed from the scalp or any part of the body, tissue is pulled out with it and appears as white coloring at the base or root of the hair. This is called "tissue tag." By examining hair for the presence of "tissue tag," it can be determined whether the hair was forcibly removed or pulled out or whether it was a loose hair that was deposited by falling out of the head or whatever part of the body it originated from. Normal brushing of the hair could also be a factor when tissue tag is present.

Three hairs from the floor around the doorway of Bell's bedroom at the Sheppard house were found to be head hair consistent with the known

head hair of Shari and found to be forcibly removed due to "tissue tags" present. One pubic hair found in the same location was consistent with the pubic hair from Shari and also found to be forcibly removed.

Hair from the Sheppards' bathroom was found to be pubic hair consistent with the pubic hair from Shari. It had been removed in the natural state, which indicated that it had just fallen from Shari's body at some time during her presence in the bathroom. Hair taken from the green, white and black rug in the bathroom was found to be consistent with Shari's head hair and forcibly removed.

From a known sample of Shari's blood, which was retrieved from the crotch of a pair of her pantyhose, SLED Serologist Ira Jeffcoat determined her blood to be Type A. Jeffcoat examined the two spots that resembled blood on the shoes collected from Larry Gene Bell's bedroom. Only one of the spots proved positive for human blood. It was tested and found to be Type A. Numerous stains on the blue mattress cover were analyzed and three were identified as semen and urine stains.

A court order was obtained to request blood and saliva samples from Larry Gene Bell, but Bell refused to give them. Solicitor Myers did not pursue the samples, thinking that with all the other evidence they had on Bell, his refusal to cooperate could be used in the State's favor.

Investigation continued with interviews of social and business acquaintances of Larry Gene Bell. Ed Bailey, a friend of the Sheppards', had started building a new home on Lake Murray in March 1985. Mr. Bailey told investigators, "I met Gene Bell around the end of March when Ellis Sheppard brought him over to start wiring my new house. He had a full beard the first time I met him in March. I kidded him and told him he needed to buy some razor blades. Gene was still working at my house in May and during that time, he shaved his beard because he said it got too hot. Later on I noticed that he was letting it grow back."

In January 1985, Sammy Collins purchased a lot down from Bell's parents' lot on Lake Murray. He told investigators that Gene came down to his lot on Saturday, June 1, around 10:30 in the morning.

We made small talk when he first got there, and I asked him, "What you been up to lately?"

He said, "I've been staying at a friend's house and looking after it for them while they are on vacation."

Then he started spouting off, "A good friend of mine's daughter was kidnapped yesterday afternoon. Have you heard about it, the Smith

kidnapping? She was a real pretty girl. I called the Smiths' house last night, and guess who answered the phone? Sheriff Metts."

I told him I hadn't heard anything about it. He walked over closer to us and handed us a bag of peaches, and came out with the statement, "She's dead, now." That's when I noticed he was cleanshaven. I had never seen him without a beard until that morning.

I made a comment to him, "Well, I see you finally shaved that hot thing off." He slid his hand across his chin and face and said, "Man, I can grow one back in a short period of time." The next time I saw him was on the Saturday before he was picked up, walking across his parents' front yard and then later sitting in a hammock in the backyard. We exchanged waves, and I noticed at that time he had grown his beard back.

North Carolina authorities assisted in interviewing acquaintances of Bell in the Charlotte, North Carolina area. Several Eastern Airline employees who had worked closely with Bell in the reservations section not only offered information as to Bell's unusual behavior but also said that they had many occasions to talk to him on the phone and in person. After listening to the suspect caller on tapes played for them, they identified the voice as Larry Gene Bell.

During the interviews, North Carolina authorities began to see similarities to several unsolved homicides in Charlotte. Sandee Cornett, a twenty-six-year-old insurance adjuster and part-time model, had vanished from her Charlotte home on November 18, 1984. She had not been heard from since. Bell worked with Ms. Cornett's boyfriend and had been to her house for a birthday party.

Denise Porch, twenty-one, had vanished on July 31, 1975, from her job as manager of a Charlotte apartment complex. She had also not been heard from since. Bell lived three hundred yards from the apartments when she went missing.

Beth Marie Hagen, seventeen, was found strangled with an electrical cord in woods near Mint Hill, North Carolina, on December 18, 1980. Bell lived in an apartment about a mile from the wooded area in Mecklenburg County, where her body was found.

On an occasion in July 1985, when Bell was being transported from CCI (Central Correctional Institute) to the Richland County Courthouse for a hearing, he started talking to Lieutenant Mike Temple of his own free will. "I want you to make arrangements for officers from Charlotte,

North Carolina, to come to see me. I want to tell them some things about a missing girl named Sandee."

Temple said, "I just let him talk." Bell babbled on, "On Monday, God is going to reveal to me where Sandee Cornett's body is." Temple said, "He also talked about two other young ladies in North Carolina that had disappeared but did not mention any names."

Temple relayed Bell's statements about a missing girl in Charlotte to Richland County Solicitor Jim Anders. The Charlotte Police Department was contacted, and Investigator Larry Walker came to Columbia Sunday, July 14, to talk to Lieutenant Temple and Bell.

Temple told Walker what Bell had said to him concerning Sandee on the trip to the courthouse. "Bell rambled from one subject to another without any real coherence. He even blurted out that he had written President Ronald Reagan about advice he had on a hostage situation that was going on at the time and wanted to negotiate with him. He would just spit out stuff like that, stop and sigh and go into the next one. Then he went on about 'and when we find Sandee's body, her hands will be like she is praying just like the Smith and Helmick case. They were crossed. Now remember, the Smith and the Helmick girls, both of their eyes were closed.'"

Temple directed Investigator Walker to CCI to see Bell. As they approached Bell he said, "Y'all are from Charlotte, aren't you? I've been expecting you. What took you so long?"

Walker said, "Yes, it is our understanding that you wanted to talk to us about Sandee Cornett."

The interview began at 2:15 p.m., Sunday, July 14, 1985. Bell said, "I will dedicate 110 percent cooperation." And that he did. He dominated the conversation throughout most of the interview, which lasted about twelve hours. The officers probably talked about 5 percent of the time.

He talked through the third person at times and then would switch to the first person. He stated numerous times that he had visions from God and that God was revealing things to him. He said, "I am the most gifted man in the world because God zaps things down to me and is using me to bring messages."

The officers said that Bell liked to be in the limelight and the center of the conversation,

> so we just let him talk, didn't interrupt him. When we did talk, our
> questions to him regarded the Cornett case and two other cases in

View from Ricky Morgan's window, showing his view of where Debra May was abducted. *Courtesy of SLED.*

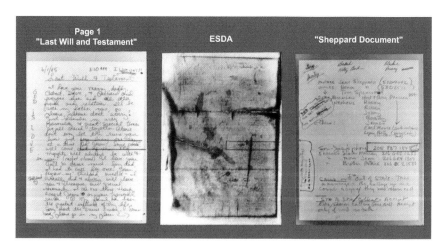

Photo chart of the first page of "Last Will and Testament," ESDA product and "Sheppard Document." *Courtesy of SLED.*

Mecklenburg County. He, on his own made some reference to Shari Smith and Debra May Helmick, and this was mainly in accord with what was in the suspect tapes. He stated that the hands of Shari Smith and Debra Helmick were crossed as in praying and that he held Shari's head and gave her a drink of water. He seemed very resolute when he stated that Shari and Debra May died with their eyes closed. He even told us that after Shari died, he cleaned everything up and put it in a green dumpster, and then he went back to the Sheppards' and took a long, cold, strong shower. He seemed to be wanting to get something off his mind. He did a lot of rambling when we questioned him more about the three cases in North Carolina, but he did tell us some things about landmarks and places that we did not know about until we talked to him on July 14.

The officers later checked out these statements and verified some of them to be true to how Bell had told them.

"The most we got from him about Sandee Cornett was him saying that through visions, God told him the way the crime could have happened."

Copies of the transcript and tapes of this interview were given to the Lexington and Richland County Sheriff's Office. Officials were surprised and interested in Bell's statements relating to Shari and Debra May and the events after Shari died but at the same time questioned how solid they were.

Murder charges being filed against Larry Gene Bell were slowed down because there were still questions of where the murders of both girls actually took place. Under South Carolina law, kidnapping is a continuing offense. It technically occurs wherever the victim is taken against his or her will. Murder is a one-time offense. If it is unclear where a victim was killed, under South Carolina Code of Laws (Title 17, Chapter 21, Section 17-21-40) a suspect can be charged in the county where the body is found.

After days of jurisdictional questions, sheriffs and solicitors of Richland, Lexington and Saluda Counties finalized the charges against Bell:

Thursday, June 27, 1985: charged with kidnapping of Sharon Faye Smith in Lexington County.

Tuesday, July 2, 1985: charged with kidnapping of Debra May Helmick in Richland County.

Tuesday, July 23, 1985: charged with murder of Sharon Faye Smith in Saluda County. The kidnapping charge from Lexington County was transferred to Saluda County and merged with the murder charge.

Friday, August 2, 1985: charged with murder of Debra May Helmick in Lexington County. The kidnapping charge in Richland County was transferred to Lexington County and merged with the murder charge.

Monday, August 12, 1985: Saluda County Grand Jury indictment for kidnapping and murder of Sharon Faye Smith. Bell was served the death penalty notice if convicted.

Wednesday, September 4, 1985: Lexington County Grand Jury indictment for kidnapping and murder of Debra May Helmick. Bell was served the death penalty notice if convicted.

Bell became cockier as legal proceedings continued. At his bond hearing he made an outburst in the courtroom, saying, "I'd like to legally request and ask that the Smith and Helmick families be allowed to put their friends on the jury that tries me. I am totally innocent of kidnapping Sharon Faye Smith and Debra May Helmick, and it will be proven without a doubt."

Although Bell proclaimed his innocence on all charges, he said he did not want to apply for bond at this time because he feared for his life.

One of the last obstacles for the prosecution before bringing a defendant to trial is the competency issue. A team of South Carolina State Hospital examiners conducted a series of tests in Bell's prison cell. The tests showed that Bell was mentally competent to assist in his own defense.

The trial date for Larry Gene Bell for the kidnapping and murder of Shari Faye Smith was scheduled for Saluda County, November 11, 1985, and the trial for the kidnapping and murder of Debra May Helmick would be in early 1986.

In preparation for trial, I took aerial photographs of the major locations of Bell's travels during the kidnappings and murders. Even though it was eighty degrees on the ground and ninety degrees in the helicopter, my thoughts of what this murderer had done to another human being had me in a cold sweat.

Later that day, SLED Lieutenant Ben Thomas and I drove to the Shiloh Trailer Park. I took photos from Ricky Morgan's kitchen window showing his view of the front of the Helmicks' trailer, where he saw Bell pull up, stop, get out and grab Debra May. What went through me then, I can't even describe.

Back in the lab I worked with the most important piece of evidence, Shari's "Last Will and Testament" to her family. For court testimony, I prepared photographic enlargement charts of the envelope, the two pages of the letter, the ESDA product of the first page of the letter and the "Sheppard Document." The enlargement of the ESDA showed the indentations of the telephone number that was initially written on the "Sheppard Document." The enlargement of the "Sheppard Document" showed entries that were consistent with indentations on the first page of the letter. These charts would be the crucial court exhibits to show what evidentially led authorities to Larry Gene Bell.

Bell did not know when he mailed Shari's "Last Will and Testament" that he was also mailing the silent witness that broke the case and stopped him: ten numbers indented in Shari's final message to her family.

A chilling observation is that the indented numbers were almost directly under Shari's words, "for Jesus. Some good." The Smiths and Helmicks were families of deep faith.

THE SMITH TRIAL

Monday, November 11, 1985, was the beginning of another week in the small farming and textile community of Saluda, South Carolina. Today would be just another day for some Saluda County residents, but for others, this day would bring much uneasy anticipation as one of the most sensational murder trials in South Carolina history unfolded.

The *State* reported that spectators milled around outside the Saluda County Courthouse waiting for the judge to allow them in the courtroom. They exchanged opinions and comments about the person who came into their close-knit, clean, peaceful community and dumped his dirty work.

The curious viewers got a look at Larry Gene Bell as he got out of the police vehicle clad in handcuffs and wearing a light brown, three-piece suit. He looked slim and his beard was neatly trimmed.

Rows of potential jurors sat nervously in the Saluda County Courthouse. Many were friends and neighbors who had known each other all their lives. Their eyes focused on Larry Gene Bell as he entered the courtroom and took his seat next to his attorney, Jack Swerling.

Jack Swerling is known as one of South Carolina's most outstanding defense attorneys. He is a bear of a man, standing about six foot five inches, and once weighed approximately three hundred pounds. He guards his clients literally, professionally and most of all with his caring. Swerling once said, "You've really got to believe in the system to do this kind of work."

Bell's parents and other family members sat behind the defense table. Lexington County Solicitor Donnie Myers was seated at the State's table.

THE TRIAL BEGINS

METRO NEWS 19 reporter Michele Nicholson reports the events of this important trial and the crime that led to a summer of fear.

A Gilbert electrician stands accused of the abduction and murder of a Lexington County teenager, a crime that shocked the state.

METRO NEWS 19
6:00 PM
WLTX 19 COLUMBIA
TV

Printed in the *Columbia Record*, November 11, 1985. *Courtesy of the* State.

Starting tonight, WIS-TV will telecast daily LIVE reports from the murder trial of Larry Gene Bell in the Saluda County Courthouse.

WIS-TV will be the only station in Columbia providing live reports on the day's events and testimony, direct from the scene of the trial.

Watch for this important story with reporter Jack Kuenzie and courtroom artist Jane Daniel, LIVE, on The 7:00 Report.

WIS TV
COLUMBIA

Solicitor Myers is known as one of the most aggressive death penalty prosecutors in South Carolina. Defense attorneys say that he thinks through cases very carefully and you always have to be aware of surprises. Myers will tell you simply, "It's good against evil, and I'm out to make sure killers don't kill again."

At the opening of the trial, Mr. Swerling asked for a change of venue, saying that extensive pre-trial publicity and media coverage may have made it impossible for jurors to hear his case impartially as the media had already influenced them on how to make up their minds.

Judge John Hamilton Smith denied the motion, and the questioning of jurors began. Swerling introduced Bell to each potential juror and asked whether they knew him. No one knew him except by watching and reading about him in news accounts.

The potential jurors were questioned in length on such issues as whether they had heard about the case, whether they could give the prosecution and defense a fair and impartial trial, whether they had formed an opinion about Bell's innocence and, in the case that he was found guilty, their feelings on the death penalty or life in prison.

Judge Smith excused some jurors simply because they said they had already made up their minds that Bell was guilty or were steadfast in favor or opposed to the death penalty. Some were excused because

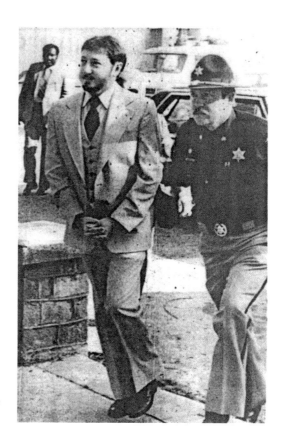

Bell entering the Saluda County
Courthouse. *Courtesy of the* State.

they said they would vote for the death penalty if Bell was convicted
regardless of any circumstances.

Bell remained quiet and took notes. But quiet was short-lived. At one
point when Bell was being escorted into the courtroom, he yelled to a
reporter, "This jury selection is taking place in a hostile situation."

Questioning of jurors moved at a slow pace Monday and Tuesday.
Early Wednesday morning, Judge Smith made a surprise announcement:
"Larry Gene Bell will not be tried in Saluda. After the last two days, I am
convinced there is probability that Mr. Bell could not receive a fair trial
in the small town and community of Saluda County."

The following Monday, Judge Smith announced that Bell's trial would
be moved to the South Carolina Lowcountry town of Moncks Corner in
Berkeley County, which is 127 miles from Saluda. The trial date was set
for January 27, 1986.

Unlike residents in Saluda County, most people in Berkeley County
probably had never heard of Larry Gene Bell, nor did they live

Bell's attorney, Jack Swerling. *Courtesy of the* State.

through the twenty-eight days that had gripped the Midlands because of him the previous June.

Berkeley County Sheriff M.C. Cannon had arranged for maximum security at the courthouse during the trial, and everyone entering the chamber was required to pass through a metal detector. Doors to the courtroom would be locked during all proceedings.

But that Monday, January 27, another snag occurred: Mr. Swerling was admitted to the hospital with a severe bronchial condition. So again the trial was postponed. The new trial date was set for Monday, February 10, 1986.

A steady rain was falling the Monday morning the trial began. Although the jail was within walking distance of the courthouse, Bell was moved to the courthouse in a patrol car.

Bell started making comments and gestures as soon as he emerged from the patrol car. He yelled, "I am Larry Gene Bell. I am not guilty." He even wore his own personal button, which read, "I am Larry Gene Bell. I am not guilty. I am the Walrus!" He continued running his mouth as he entered the courtroom, proclaiming, "I am innocent and will not get a fair trial."

The family of Shari Smith was present in the courtroom as Bell was escorted in. Their heads turned slightly and then they quickly looked away.

Jury selection got underway. After the first recess when Bell returned to the courtroom he loudly remarked, "Your Honor, for the record, I'd like to state that Gene Bell is not a vicious, mean, dangerous individual and anyone that can say otherwise doesn't know me personally."

At that time Mr. Swerling escorted his defendant to the back room for a conference. They returned to the courtroom after only a few minutes. Bell took his seat while the attorneys and judge had a brief conference at the bench.

Jury selection resumed. During questioning Bell stood up and abruptly said to Judge Smith, "Why in the hell am I being held at the gates of

Solicitor Donnie Myers. *Courtesy of the* State.

hell for this crime that I didn't commit? Explain this to me."

Judge Smith quickly ordered him to be quiet and be seated or he would have him removed from the courtroom for the rest of the jury selection.

Jury selection went much faster than in Saluda. However, some potential jurors were excused because they had knowledge of the case and had already formed an opinion of guilty or did not believe in the death penalty.

A forty-year-old housewife was excused when she said, "My conviction on the death penalty is that it hasn't been used enough. We need to dispose of people who kill innocent children."

A forty-year-old construction foreman told Judge Smith that Bell was guilty and didn't deserve a trial. "If it would have been one of my children, they wouldn't be having this trial." He was excused.

One lady said she did not have an opinion, but she thought Bell was guilty because he looked guilty, and she was excused.

Outside the courthouse at the end of the day, Bell blurted out, "It's a shame that I have to be judged by people who tell you, you look guilty. Gene Bell did not do this."

Tuesday morning, Bell spoke up as he entered the courtroom. "My silent friends, whatever the legal outcome of this trial is, I pray daily that the Smith and Helmick family, as the Bell family, can constructively go on with their lives."

Jury selection resumed, and at one point Bell appeared to be crying. His sobs continued off and on during the day until he finally spouted out, "Your Honor, I can't take this anymore. Gene Bell is not responsible for this. This is not right. I want to see my doctor. This is not right."

Mr. Swerling spoke, "Your Honor, I want to state for the record that Mr. Bell right now is not able to participate, and I ask for a recess briefly so we can decide what to do. He is not in any way communicating with me."

Judge Smith answered, "Well, we will take a brief recess, but Mr. Bell, let me say this to you. I know this is a difficult time for you. I hope, also,

that you understand that we have got to go through this procedure of jury selection, and we need to accomplish that without your outbursts. We are going to proceed with this jury selection process whether you are present in the courtroom or whether you are not present in the courtroom. As long as you can conduct yourself properly, we are glad to have you. If you cannot, then we will remove you from the courtroom, but we would still proceed with our jury selection."

Court continued after the recess, and the jury selection continued smoothly. Bell remained quiet the rest of the day. Court convened on Wednesday morning, February 12, with a "good morning" from Judge Smith. Almost like an echo, Bell spoke up with, "Silence is golden."

Jury selection concluded Wednesday afternoon with a seven-woman, five-man jury seated. The jury was sworn in on Wednesday, February 12, 1986.

Solicitor Myers began his opening statements to the jury.

> *You were chosen to sit in judgment in this case where Larry Gene Bell is charged with murder, a most heinous crime known to mankind, the taking of a life, a life of someone you and I will never see, a beautiful seventeen-year-old, talented young girl named Sharon Faye Smith. Witnesses called will present the evidence. Listen to that. Listen to the events. You are the judges of the facts. Decide what the truth is. Return a verdict that speaks the truth, nothing more, nothing less. Thank you.*

Mr. Swerling then addressed the jury.

> *In our country and in our state, everybody is entitled to a fair and impartial trial. You will hear a bunch of facts from the witness stand and view exhibits and documents of facts. I want to tell you right up front ladies and gentlemen that this is the ultimate human tragedy, the death of a human being. The ultimate human drama will unfold right before your eyes, but you need to keep everything in perspective that you are going to have to decide this case, not on the tragedy that came about, but on what evidence is presented and what the judge instructs the law is. I wish you luck in arriving at a fair and just verdict. Thank you.*

Shari's boyfriend, Richard Lawson, was the first witness called by the State, followed by her friend, Brenda Boozer. They gave the events of the Friday afternoon before her abduction.

Shari's father, Robert Smith, told the jury of his actions the Friday afternoon of Shari's abduction and of the phone call coming to his house at 2:20 a.m. Saturday morning, which led authorities to transport him to the Lexington Post Office to sign for the letter addressed to the Smith family.

Solicitor Myers asked Mr. Smith if he had received any more calls to his home that day or the next day or during the week.

"Yes, sir, we received some other calls like this several more times."

"And who did the caller talk to, mainly?"

"Well, at first the caller talked with my wife, Hilda, then later demanded that he talk only with Dawn, my other daughter. He would not talk to anyone else, and if anyone else came to the phone the caller threatened to hang up."

Mr. Smith was then asked if he knew Larry Gene Bell.

"No, sir."

"Did you even know he existed on May 31 or June 1 of 1985?"

"No, sir."

Mr. Swerling had no questions for Mr. Smith.

Mr. Ballinger, one of the witnesses who passed by the Smiths' residence at the approximate time of Shari's abduction, took the stand. He told what he observed that Friday afternoon and the description of the driver of the car that was stopped next to the pavement and mailbox where he saw Shari standing.

The next witness, Mrs. Butler, also described the man driving the car that almost ran into her in front of the Smith house and then pulled over to the side of the road near the mailbox.

Assistant Solicitor Knox McMahon asked Mrs. Butler if she would look around the courtroom and see if she saw the man who was driving the vehicle that almost struck her there at the Smith residence on the afternoon of May 31, 1985.

"Yes."

"Would you point him out?"

She pointed to Larry Gene Bell, sitting next to Mr. Swerling.

"Any doubt in your mind, Mrs. Butler?"

"No!"

"Anything different about him today than when you saw him on the afternoon of May 31, 1985?"

"He has a beard, and his hair is combed down."

Sammy Collins told of his meetings with Bell at his lot on Lake Murray and Bell talking about the Smith kidnapping when he came over on

Saturday morning, June 1. "Bell had a beard when I first met him in February 1985. He was cleanshaven the morning of June 1, and around June 22, his beard had grown back."

Next to testify was Shari's mother. Solicitor Myers prodded her gently as she told of the events of the Friday afternoon of Shari's abduction and the phone call she received from the caller in the early morning hours that Monday telling them they would be receiving a letter from Shari in the mail.

Solicitor Myers asked her if they had received any more phone calls from the same caller.

"Yes, we did."

"Who did the caller want to speak with during the first several calls?"

"He wanted to speak to Shari's mother."

"And some of the last calls about the middle of these calls that you received, who did the caller then want to speak with?"

"My other daughter, Dawn."

"Later on that same day, Monday, at about 3:08 p.m. that afternoon, did the caller call back wanting to talk with you again?"

"Yes."

"And this would be the second call, but the first one that was recorded."

"Yes."

"Your Honor, at this time we'd like to offer that tape into evidence."

The tape was played for the court and jury. When the tape ended, Solicitor Myers asked Mrs. Smith, "Was the caller on this tape the same caller that called you before daylight that Monday?"

"Yes, it was."

The tape of the third call to the Smiths' residence at 8:07 p.m., Monday, June 3, 1985, was introduced into evidence and played for the court and jury.

Solicitor Myers spoke to Mrs. Smith, "In this telephone call he referred back to talking to you the first time on Monday morning at 2:20 a.m., and he also said, like in the letter, casket closed and folding her hands in the casket like she was praying. Was it after this call that we just heard that the caller started wanting to talk to Dawn?"

"Yes, he did."

"Now, the person that called you, the times you were listening to him on all of these calls or the times that you were talking with him, was it the same person calling?"

"The very same person all the time."

"Do you remember that voice?"

"Oh, yes, I can't forget that voice."

"Did you know Larry Gene Bell prior to Shari being missing?"

"Never seen him. Didn't know him."

"Prior to May 31, did you even know this person existed?"

"No, I did not."

The tape of the fourth call to the Smiths, dated Tuesday, June 4, 1985, was now offered into evidence and played for the court and jury. After Mr. Myers talked to Mrs. Smith about that tape, he said, "Then a call came in the next day, Wednesday, June 5, just before noon, approximately 11:54 a.m.—A short call giving directions."

"Yes."

This was the fifth call from the anonymous caller that came into the Smiths' home. Solicitor Myers offered that tape into evidence, and it was played for the court and jury. As the tape played, Mrs. Smith could not hold back her tears. After a few moments of silence, the solicitor asked, "Mrs. Smith, did you get to respond to him at all during this call?"

"No, I did not."

"And he was talking about the traffic circle down toward Saluda. Your daughter's body was found down there?"

"Yes, sir."

Solicitor Myers said, "I want to jump ahead to Thursday, June 27, 1985." He questioned her about when she and Dawn went to the sheriff's department to talk to Bell.

"Had you ever seen his face before that day?"

"No, I had not."

"When you talked to Larry Gene Bell that day, how did the voice compare with the person's voice that made those telephone calls?"

"I had heard that voice over and over, even when I tried to go to sleep at night. I couldn't cut that voice off, but it didn't have a face. When I heard Larry Gene Bell talk, then I had a face that went with that voice I had been hearing over and over again. Larry Gene Bell was the voice, and he had been caught."

Mrs. Smith again broke into tears but strongly told the court, "I'm fine and can continue."

On cross-examination, Mr. Swerling was brief. He asked Mrs. Smith, "There is no question that you did not know and had never seen Larry Gene Bell before, is that correct?"

"I did not know him and had never seen him."

"Thank you, Mrs. Smith, that is all I'm going to ask you."

Shari's sister, Dawn, followed her mother on the stand.

Dawn told that she stayed at her parents' home during the entire ordeal, so she was there when the phone calls started coming in. "At first the caller wanted to speak to my mother and later started asking to speak to me."

The tape of Thursday, June 6, 8:57 p.m., was played for the jury. Solicitor Myers asked Dawn if this was the last call that they received from the caller.

"No, we received more."

"So he didn't kill himself the next morning like he told you he was during this call?

"No, sir."

"Was there a call that day after Shari's funeral, Saturday, June 8, around 2:21 p.m.?"

"Yes, sir."

"And again you talked to him?"

"Yes."

The tape of the call Saturday, June 8, 2:21 p.m. was played for the jury.

"Now, Dawn in this tape he said he was going to kill himself again, and they would find pictures in a plastic bag on his body. Did he kill himself and did you ever find the pictures he was talking about?"

"No."

Myers also jumped ahead with Dawn to Thursday, June 27, 1985, when she and her mother went to the sheriff's department and talked to Bell.

"Dawn, prior to that day, June 27, had you ever seen Larry Gene Bell before or even knew he existed?"

"No, I didn't."

"How did the voice that you heard coming out of Larry Gene Bell's mouth that Thursday compare with the voice on the telephone calls that you all were receiving?"

"It was the same voice."

"Any doubt in your mind?"

"No, sir, none."

Charlie Keyes, WIS-TV news reporter, was called to the stand. He was asked about the call that came into the news department at the station on the afternoon of Thursday, June 6, 1985, around 2:30 pm.

"Did you have any type of recording equipment already in place on your phone that afternoon?"

"Yes, I did."

This tape was then played for the jury.

"Please tell the court what arrangements, if any, were made because of this phone call."

"Two law enforcement officers spent the night with me in my house and escorted me to Sheriff Metts's house in Lexington County early the next morning well before six o'clock. We waited inside Sheriff Metts's house for a couple hours."

"And did the caller turn himself in that morning at 6:00 a.m., to your knowledge, as he said he would?"

"No."

Dr. Joel Sexton gave his account of the preliminary examination of the body at the crime scene. He explained,

> In forensic pathology, it is important to try to get as many facts as possible in order to try to understand the circumstances surrounding the death to try and determine the cause of death. It is very important to try to see the body at the scene of death or at the scene where the body is found, because if the body is moved there is always the possibility of evidence being lost from the body from a medical standpoint. It was obvious that the body had been dragged from a clear area through this high grass and high shrubs to the area where it was found because the shrubbery and grass had been pushed down by the body being dragged.

He hesitated briefly and then continued softly.

> After a person dies, in addition to the blood settling to the bottom of the body, the cells individually die. When they do die, they release an acid into the body system. This acid acts the same way on the protein in our muscles that the heat in a frying pan does on the protein in an egg, tends to solidify it, so the muscles become solidified, and they become frozen or in a state called rigor mortis. After a period of time of about six hours, the body is totally rigid so that if it is moved to another position, it has the same configuration it had earlier, and it may look abnormal. There was no rigor mortis present, which indicates that the body had been dead at least two days in normal room environment because the rigor mortis had come on, become fixed and it had disappeared. Decomposition was present. Flies had laid eggs, and maggots and beetles were present. This is the normal process in nature of destroying a dead carcass found in the wilderness.

The jury listened, eyes closed, heads shaking and some appeared to be on the brink of tears.

Dr. Sexton continued into the autopsy and explained to the jury that because of decomposition, no determination could be made as to whether sexual intercourse had taken place, nor could he make a definite determination of death. He could only establish that Shari died either from ligature—smothering-type strangulation—or from her medical condition.

Mr. Swerling cross-examined and reiterated the fact that Dr. Sexton had not been able to come to any conclusion about sexual activity and that the cause of death could have been from her disease.

Ellis and Sharon Sheppard testified and gave details of when they first met Larry Gene Bell and their everyday association with him right up to his arrest. They noted when he had a beard and when he was cleanshaven. He stayed in their home from May 13 until June 24, 1985, while they were away on vacation. They wrote instructions, notes and telephone numbers of relatives on a yellow legal pad in their home in case he needed to contact them when they were away. They identified the telephone number that was derived from indentations on the "Last Will and Testament" as their son Joey's in Alabama. They told how Bell talked about the Smith case and was totally obsessed with it, and when the tapes were played for them, they immediately identified the voice as Larry Gene Bell.

SLED Questioned Document Examiner Mickey Dawson took the stand. He explained how they had used the ESDA procedure to check for indented writing on the "Last Will and Testament" letter, and after using a combination of numbers from the faintly visible indentations of the numbers on the ESDA, the numbers were found to be the telephone number of the Sheppards' son in Alabama.

Agent Dawson displayed to the jury the photo chart of the first page of the "Last Will and Testament," the ESDA product of the first page of the "Last Will and Testament" showing faintly visible indentations of letters and numbers and the "Sheppard Document" showing the telephone number of their son in Alabama. He had prepared an exact size transparency overlay of the ESDA product showing the indentations of the numbers. He moved the transparency from one photo to the other, showing the relationship to each of how the "Last Will and Testament" had been written on the sheet below the "Sheppard Document."

He also told the jury, "I compared the known handwriting of Sharon Faye Smith to the handwriting in the 'Last Will and Testament' and positively identified it as Shari's handwriting."

When court opened on Saturday morning, February 15, Bell entered the courtroom and approached the judge's bench. "Your Honor, I'd like you to advise my attorney what happened yesterday afternoon concerning me. It upsets me, it blows things out of proportion and you know because you were advised from SLED. You know exactly what I am talking about."

Mr. Swerling quickly spoke up, "Your Honor, can I take him outside?"

Speaking to Mr. Bell, the judge said, "Go ahead and talk to your lawyer."

When Mr. Swerling and Bell returned to the courtroom, Mr. Swerling sat Bell down and then approached the bench.

After a short discussion, Judge Smith addressed the court.

> Let me put on record a little background. Yesterday afternoon when we took our recess for the day, Lieutenant Sam Frierson with SLED approached me and said that the defendant was not handcuffed when he was being led out of the courtroom. It is SLED's regulation that if a person in their custody is not handcuffed, then the person should not have anything about their person that could conceivably be used as a weapon. So rather than handcuff the defendant as he was being brought in and out, Lieutenant Frierson suggested that a pen be taken from him for that short period of time. So we will not deprive Mr. Bell the use of the pen in the courtroom or at the jail. It is just those times when he is not handcuffed. This is just part of the regulations, and they will be followed.

Bell came back, "Your Honor, I do not accept your apology, which you did not give, but I do not accept it."

Judge Smith addressed him, "I wasn't apologizing. Bring in the jury."

Later that day Bell was brought to the stand for a short testimony on signing consent to search forms. He spoke out, "Because of Old English Law in the 1800s, I rise at the witness stand."

Judge Smith said, "Fine, just stand then, but I advise you to listen to the questions and try to confine your answers to the questions."

"Yes, sir, I will cooperate 110 percent, but can you imagine when you are at the gates of hell. I live with this twenty-four hours a day, but I can't come close to relating what the Smith and Helmick families have been

through. They are at the gates of hell. I am at the gates of hell. They are in hell. Let's get this over with and go on with life. That's the way I feel."

After brief questioning and Bell's rambling answers, Judge Smith told Bell that he could step down.

SLED Agents Ken Habben and Mickey Dawson testified to their search and findings of the Bell and Sheppard residences.

SLED forensic chemists testified to the analysis of hair, fibers, blood, semen and urine that was found at the Sheppard and Bell residences and their consistency with those of Shari. They also brought out that Larry Gene Bell refused to give blood samples, but if he had cooperated the results could have included him or positively excluded him.

Eastern Airline employees and Charlotte acquaintances of Bell told the jury that the voice on the tapes that were played for them was the voice of Larry Gene Bell.

As the trial entered its second week, Monday morning, February 17, which was a federal and state holiday, the courtroom was filled. The trial had become so popular that spectators would leave personal belongings in their seats when they got up during breaks in hopes of saving their spot.

As soon as Bell entered the courtroom that morning he spoke up, "Your Honor, off the record…"

Judge Smith quickly interrupted, "You'll have to wait until Mr. Swerling comes in."

Swerling was slightly delayed due to the fact that he had just conferred with Bell's psychiatrist, Dr. Harold Morgan. They were concerned about Bell's state of mind during his interview with the Charlotte authorities, in which he gave statements regarding the Smith and Helmick cases.

Without the presence of the jury, Dr. Morgan told the court that Bell's conversation and rambling during the interview were full of delusions, which simply meant false beliefs, and that Bell was out of touch with reality. The medical term for the condition would be "psychotic."

Judge Smith reviewed the transcripts of the Charlotte officials' interview with Bell. He found that Bell's statements, which resembled a confession, were given voluntarily and met the Miranda and waiver standards. Judge Smith allowed Richland County Detective Michael Temple to testify regarding Mr. Bell, telling him he wanted to talk to some other police officers while he was transporting Bell to a hearing on July 12, 1985, but not allowing Temple to testify on what Bell voluntarily told him during the trip.

Charlotte Investigator Larry Walker was allowed to tell of his meeting with Detective Temple and that Bell had requested to talk to him and

other officers. Walker was only permitted to impart what Bell said to him in regard to Shari Smith. Absolutely nothing could be said about Debra May Helmick or the North Carolina cases.

Walker shared what Bell had said to him relating to Shari's hands, how he held her head and gave her water and how her eyes were closed when she died. Then he shared how Bell went back to the Sheppards', cleaned everything up, disposed of it in a dumpster and after it was all over took a long, cold, strong shower.

Walker said, "He stated numerous times, 'I am the most gifted man in the world because God zaps things down to me and is using me to bring messages.'"

In cross-examination by Mr. Swerling, Walker was asked about Bell's comments about being the most gifted man in the world and God zapping things down to him and God using him as a messenger. "Do you think he was acting in an unusual manner?"

Walker responded, "Yes sir, at times throughout the interview, Larry Bell did act in an unusual manner, and I will emphasize the word act."

"Thank you, no further questions."

Mr. Myers followed, "With that witness, the State rests."

Court was recessed until 2:15 p.m. that Monday afternoon, at which time Bell's attorney, Mr. Swerling, began with the defense testimony.

Testimony was heard from a clinical social worker and psychiatrist from the William S. Hall Psychiatric Institute in Columbia.

> *We had been involved with diagnostic interviews and evaluations on Larry Gene Bell in 1975 and 1976. Bell told us, "My express wish is to find out what makes me lose control and attack girls." When Bell was asked about his background and family history he told us that his mother had died approximately seven years before of abdominal cancer. This was the first time we had ever run into anyone killing off his mother with abdominal cancer when she wasn't even dead. Bell was diagnosed as immature personality, which is a long-standing pattern of behavior that didn't seem to change over the years. Treatments were scheduled, but he only showed up for one. In February 1976, he came back to the outpatient clinic and asked for a voluntary admission to the Hall Institute. Bell remained in the Hall Institute in a controlled setting for almost three months.*

Another psychologist told the jury that he interviewed Bell, and he used the term "cognitive slippage" to describe his function. "This term is more

professional jargon than anything else. It means that most of us think in logical terms, but Bell's logic was not as precise as you might have wanted it to be. At times he showed signs of thought disorder and borderline psychosis, which means not thinking logically."

Mr. Swerling asked, "Doctor, based on all your tests, would your conclusion be that Mr. Bell was mentally ill when you saw him back in 1975?"

"Yes sir, in my opinion, he was in 1975."

Cross-examined by Mr. Myers, the doctor was asked, "By mentally ill, you don't mean out of touch with reality or insane, do you Doctor?"

"Not in any sense of the word."

"Thank you. That's all I have."

Mr. Swerling then called Bell to the stand. Swerling asked him to state his name, to which he replied, "Larry Gene Bell."

"How old are you, Mr. Bell?"

Bell replied, "Silence is golden." He pointed to Swerling. "May I confer with him?"

Swerling spoke up quickly. "May I take him to a back room?"

Judge Smith replied, "Sure, and because it is 5:15, I am going to recess court until nine o'clock in the morning."

The next morning, Mr. Bell returned to the stand and once again stood because he said there were no chairs at the gates of hell.

When asked where he was born he said, "Ralph, Alabama; R like Robert, alph, like a dog. I'm a Halloween baby, born on October 30, 1949." He rambled on about his childhood, how talented he was and how he just loved to help people. "My mom and dad had at one time moved to Tupelo, Mississippi, home of Elvis Presley, and my uncle gave Elvis a job as a truck driver when he was a teenager. That's wild, isn't it?"

Bell brought up his honorable medical discharge from the U.S. Marines because of his knee injury, then pulled up his pants leg to show the jurors this injury.

After this went on for about an hour and forty-five minutes, Judge Smith interrupted, "Excuse me, Mr. Bell, you can go ahead and step down. We need to take a break."

After the break, Bell continued talking about his work as a correctional officer and then on to Eastern Airlines. "I was kind, honest and had plenty of friends that loved me. I had this little Indian Princess. Her real name was Cereta. If you change the C to M and e to i you would have

Merita, like the bread. All I could figure was that her mother went to a store and bought a bad loaf of bread and that is how she got the name."

Heads were shaking all over the courtroom on that one.

He went on to his marriage and the birth of his son, Cody Daniel Bell. "He is my treasure, and I don't want to talk about that anymore. Then I got divorced."

He kept bringing up the gates of hell, which appeared to represent his jail and prison cell.

Swerling asked Bell if he got anything out of the treatment he had received at the mental institute.

"No, no matter what the doctors say, I am mentally ill. I have never done a vicious, mean, dangerous crime. They said I was holding back, but we all know it's important to cooperate with the doctors because that can save a person from the electric chair, and get a person a guilty but mentally ill verdict…food for thought."

Quickly Judge Smith said, "Please disregard Mr. Bell's last statement."

Swerling called for a sidebar (discussion between judge and attorneys at the bench). He objected to any controlled or cutting off of questions Bell was asked. "The defense believes the jury is entitled to see and hear the defendant as he answers questions and the manner in which he answers them."

Judge Smith replied, "All right, of course the record will reflect the number of times, and what I said in regard to those times that I interrupted him, but I am not, Mr. Swerling, going to turn over the conduct of this trial to you or Mr. Bell."

Judge Smith announced to the court, "We will be in recess until 2:15."

During the break, Bell approached Myers, saying, "You're the best."

Myers responded, "Not yet, I'm still waiting to get you on the stand."

Court reconvened, and as Bell sat back down at the defense table, he turned to reporters and said, "I'm so confused. Ain't we having fun?"

Judge Smith reminded Bell, "You are still under oath. Just come on up."

Bell's response was, "Thank you, honorable Judge Hamilton Smith."

Swerling questioned Bell about his incidents in Charlotte and about the jobs he worked at doing odds and ends. Most of his answers were again a lot of rambling, but he did seem very proud when he told the jury of a business he set up selling cords of wood. "I called it 'Gene's Wood Chuck.' Kind of catchy, huh?"

During the lingering hours of Bell's testimony, Solicitor Myers had remained silent but finally felt the need to speak up. "Your Honor, for

about six hours now we have not said anything, so I think it is time to start objecting to the relevancy."

After another brief conference at the bench, Swerling asked Bell about his relationship with the Sheppards.

"I started working for 'Uncle Ellis' near the beginning of the spring or summer of 1985. I felt really comfortable with him and started calling him 'Uncle Ellis.' Naturally, I called Mrs. Sheppard 'Aunt Shari,' but didn't feel comfortable with it, so I only called her that one time. The Sheppards trusted me totally and asked me to babysit their house and animals when they went on their trips. I didn't stay there all the time though, because I had to check on Mama and Daddy, too, so I would spend like two or three nights a week there, but it was very rare that I would spend a weekend over there."

Swerling asked, "Larry, did you shave your beard after the Sheppards left on their first trip in May?"

"Yes, during the winter, I just let my beard grow long, but I keep it neat. Then during the summer, I summerize my beard. I shave it. I had just cut it a couple of days before a hypothetical date happened. On a Friday, and you all will just have to read between the lines there. May 31, if that falls on a Friday, which I know it does."

"So, Larry, on this Friday, May 31, did you see Shari Smith?"

"Are you talking physically? Because there are visions, and there are physical things."

"Yes, physically, did you see her?"

"No, this is very bizarre, very unusual...so I had a vision of Shari Smith, and I shall not explain it because the family is present, and that is creeping over into the personal life and to me here. They have been through enough and silence is golden."

Judge Smith spoke up. "It is time for a recess."

Bell responded, "Hallelujah for that."

"Just please step down, Mr. Bell."

As the jury retired to the jury room, Judge Smith replied, "All right Mr. Swerling, Mr. Bell has been on the stand for approximately six hours or longer. That is certainly enough time for the jury to be able to observe his demeanor in answering the questions. I have noticed that Mr. Bell understands the questions that he is asked and that his answers are lucid. Mr. Swerling, if you do not choose to limit your client in his responses to the questions you ask, then I am going to do so. If not, we may be here for the next three weeks."

Bell blurted out, "I am ready for that."

The jury returned to the courtroom, and Swerling continued with Bell. "Is that your voice on those tapes that we listened to this week?"

"No. Do not be deceived by electronic voice recording. With today's modern high technology, anything is possible. As I stated earlier, with respect to the family, silence is golden."

Moving along, Swerling asked, "Do you remember the report of another abduction in Columbia on June 14, two weeks after the Smith abduction…young girl named Helmick?"

"Yes, on a Friday. No, I am looking through a vision. I saw a vision… somebody else doing it."

Swerling asked, "During that period of time, did you call or tell anyone who the people were in your visions?"

"Yes, I called *Crime Stoppers*, and told them that I had some information concerning the cases involved. I even gave them the name of the suspect."

"And where did you obtain that information from, Larry?"

"From a vision."

"Do you want to talk about it further, and tell us who it was?"

"No, can you see the legal loopholes there, honorable Jack B. Swerling, my professional teddy bear? The man that did that is still probably out there wandering around."

Swerling passed that by and went on to the interview with Mr. Walker. He asked Bell about a young lady missing from North Carolina.

"I talked to them through a vision. I wasn't personally involved, but this one I knew all the behind-the-scene details. I learned all about it through the news media."

After seven hours of this, Swerling sighed and turned away. "I don't think I have any more questions for him."

Judge Smith looked at Bell and said, "Step down Mr. Bell," and announced that court was adjourned for the day.

Wednesday, February 19, the tenth day of trial, Solicitor Myers began his cross-examination of Bell. "You were arrested for an incident that had something to do with a blond-haired girl and a knife in 1975 in Rock Hill, South Carolina?"

"Yes sir."

"As a result of this arrest, you went to the Hall Institute for the first time, and this was the first time you talked to a psychiatrist or psychologist."

"Yes sir, you have a good memory."

"So do you, Mr. Bell."

Bell grinned and said, "Thank you."

"I think you said that when you went there it was something about some help for attacking females."

"Yes, sir."

"They gave you probation on the Rock Hill incident, so you didn't see a need to keep any more appointments with the Hall Institute?"

"No, sir."

"Then there was the incident with you and the USC student on October 30, 1975, and you were given a sentence of five years and turned yourself back in to the Hall Institute again, November 4. You told them again that you wanted to discuss treatment for attacking females."

"Yes, sir."

Myers continued, "And if it wouldn't have been for the doctors testifying for you, you might have received a thirty- to forty-year sentence."

"Yes, sir, honorable Solicitor Donald V. Myers, I thought I was going to be off today, sit back and let 'teddy bear' earn his money."

Myers just continued. "In December 1976 your divorce was final."

"Unfortunately, yes."

"Now, you said you went back to Charlotte, and in 1979, you got into another incident with obscene phone calls, and this one involved another blond-headed girl, ten years old, and her mother. They lived right across from you in the same apartment building."

"Yes, sir."

"So, in between all these incidents, you were in and out of institutions seeing doctors, psychiatrists and psychologists?"

"Yes, so many of them. You are good. I know you y'all don't miss anything. The Statewis good."

"Do you remember telling two doctors that you just made up these stories about having visions and blackouts of these incidents just to prepare for court and not be punished in court?"

"Oh! Yes, sir."

"Also, you said that all these crimes that you talked about, you are not guilty of any of them."

"Yes, sir."

"Mr. Bell, did you go to the highway department in the latter part of 1984 and in March of 1985 to transfer titles and get license tags for some vehicles?"

"Yes, sir."

"Mr. Bell, do you deny telling Mr. Collins when you talked to him that Saturday morning, June 1, that you were good friends with the

Smith family, and that they had a beautiful daughter who had just been kidnapped and was now dead, and you had called the Smith family and Sheriff Metts answered the phone?"

"Yes, sir, I sure do."

"They didn't have all that on television. No way could you have known that. Matter of fact Sheriff Metts wasn't even present with the family. Where did you hear this from, Mr. Bell?"

Bell came back with something about walking down to a boat ramp, and somebody said something to him about it.

Solicitor Myers tried to get back into the question, but Bell started rambling around it and again Judge Smith interrupted. "Mr. Bell, Mr. Bell, I am telling you. I know you hear the question, just answer it."

"He won't let me."

Myers left that one and asked Bell, "You said that before you were arrested you had visions about three girls, the Cornett girl, the Helmick girl and Shari Smith. Is that correct?"

Bell asked Judge Smith to please have him ask him one question at a time.

Myers did just that. "Before you were arrested on June 27, you had visions about Sandee Cornett from Charlotte, North Carolina?"

Bell responded, "Repeat the question, I was preoccupied with something else."

"Before you were arrested on June 27, you were having visions about Sandee Cornett from Charlotte, North Carolina?"

"No."

"Before you were arrested on June 27 of last year, did you have visions about Debra May Helmick, the little girl from Richland?"

"Let's see, before I was tossed unjustly at the gates of hell. No."

"Then if you didn't have visions of Sandee Cornett or Debra May Helmick before you were arrested, whatever visions you had were after you were put down in your cell at CCI that you call the gates of hell."

"1985, yes. The reason I was having the visions was because I was being charged."

"Then your arrest is what brought on your anxiety?"

"Pressures because I am charged with this, but I still say it is all visions…visions through God."

Myers tried to get Bell to break and talk about his visions of Sandee Cornett or Debra May Helmick, and Bell came back with his constant, "Silence is golden, my friend."

"You don't want to tell anything about this?"

"Correct, yes, sir, but naturally I am protecting myself legally in the eyes of the law, because I am not going to confess to something I am not responsible for. Give me liberty or give me death."

Myers asked again, "Did you have any visions of Shari Smith before you were put in CCI or after you were put in CCI?"

Bell continued on his roll. "Apparently you don't do your homework at night. You should have reviewed what I said yesterday. Silence is golden, my friend. You are still the honorable solicitor, but the family has been through enough. There is not much more I can be put through unless you are going to chain me to the bed and beat me and gas me."

Judge Smith spoke up, "All right, Mr. Bell."

"I am sorry. I take that back."

Solicitor Myers continued, "How was Shari Smith abducted?"

"Silence is golden."

"Isn't it true, Mr. Bell, that you told some officers that you saw Shari Smith in that parking lot in your visions?"

"In my visions? Ok, here we go again. Boy, you never stop. Silence is golden, my friend."

"Didn't you tell some officers that Shari Smith left the shopping center and how she was abducted with a .38 gun in front of her house by a mailbox?"

"Silence is golden, my friend."

"Ok, as a result of your visions, didn't you tell Officer Walker on July 14, 1985, at CCI that Shari Smith's head was held up, given a drink of water and given a choice of how she would die?"

"There again you want me to answer something, and I am not going to incriminate myself and confess to something. Silence is golden."

The judge finally stopped all this and broke for lunch.

Court resumed around 1:30 p.m. Myers continued with Bell. "On July 14, when you talked with Officer Larry Walker, you said you had visions. You said before, it was because of the family being present that you would not tell us what you told him. I had the Helmick and Smith families stay outside, so they are not in the courtroom. Will you tell us what you told the officers on July 14 as to any visions involving Shari Smith?"

"No, sir, same applies as above. Silence is golden, my friend."

"Ok, Mr. Bell, while you were in the Maximum Security Center, on September 13, 1985, you were transported to Lexington by SLED Agent Ronnie Sims, and you told him they wouldn't let you have a pen or pad or newspaper, and you couldn't hear the news on the radio or television."

"That is correct."

"And on that same day, you also told Agent Sims that you didn't need a newspaper and you didn't need the news because you knew what happened because you were there."

"Crystal ball, yes, sir, I remember that. Through visions, yes, but I'm not going to tell you about them now…courtesy to the family."

"The family is not in the courtroom."

"If I tell it in open court, it goes around the free world."

"Mr. Bell, I'd like to ask you this. While you were in the Maximum Security Center, the correctional officers were outside your door, and sometimes you would talk to yourself, or to the wall."

"I would say yes. I like to talk to myself, but I was protecting myself legally under the eyes of God."

"And on July 11, 1985, around eleven o'clock, did you make the statement, 'I thought I threw that telephone pad away?'"

"Yes, I did."

After a tense two-hour exchange with Bell, Solicitor Myers ended, "I have no further questions of him."

Officer Joseph Rogers with the Columbia Police Department and the *Crime Stoppers* program testified to a phone call that was received shortly after midnight on Sunday, June 23, 1985. "The caller said it was in reference to the Smith kidnapping in Lexington. He said the suspect had access to a Chevrolet Monte Carlo and to a white Buick and that he was housesitting in Gilbert on the Lake Murray side. He would not give me an address."

Mr. Swerling asked the witness, "Did he give you a name of the suspect?"

"Yes, sir, he gave me the name, Larry Gene Bell, and even went further and gave me a description of the suspect and that he had a history of child molesting blond-headed girls."

Swerling said, "You listened to a tape of a phone call made to the Smith family. Had you ever heard that voice before?"

"The voice on the tape sounded similar to the voice that I heard on June 23, when I took the phone call."

Swerling asked the officer if the case was significant to him or if it was just another call, and he answered, "Just basically another call. We received a lot of them that weekend concerning the two kidnappings."

"And what did you do with the information?"

"Wrote it down on the *Crime Stoppers* form, and the next morning Sergeant Bill Oliver picked it up."

Sergeant Oliver's testimony followed. He was asked if he had received the copy of the *Crime Stoppers* report recorded June 23, 1985.

"Yes, sir. There were quite a number of them that Monday morning."

"Did you act on it at that time?"

"No sir, not at that time. On curiosity, it was after I saw that he was arrested. I saw the name in the paper. I was curious to see if we had obtained any information, and then it was brought to my attention that Larry Gene Bell's name was mentioned."

"So what did you do with the report when you got it that Monday morning?"

"Basically, I processed it, which consisted of having it typed up and duplicate copies made. They were taken over to Lexington County Sheriff's Office on Monday or Tuesday, along with at least twenty-five other reports that came in over the weekend."

Myers cross-examined, "You said you went back and looked for that report after he had been arrested."

"Yes, the name meant nothing to me until I saw it in the paper."

After a short break, Mr. Swerling introduced into evidence three tape recordings of statements taken of Mr. Bell on June 27, the day of his arrest: Lieutenant Perry and Lieutenant Davis and Bell; Sheriff Metts and Bell; and Hilda and Dawn Smith and Bell. Once again, Swerling said that these would show Bell's state of mind on that particular day.

For three and a half hours that afternoon, the jury listened to the tapes. At certain times, Bell would shake his head and laugh, then appear to be crying.

Playing of the tapes continued for about three hours the following morning, Thursday, February 20.

Myers finally objected, saying, "There should be sufficient enough evidence to show the jury Mr. Bell's mental state by now."

After the tapes, the defense requested to have several other witnesses testify.

A correctional officer with the Central Correctional Institution Maximum Security Center where Bell was housed gave testimony of Bell's behavior during his incarceration.

> He lived in an eight-by-six-foot cell. He was placed on observation by camera as well as having an officer outside his cell twenty-four hours a day. At times, he would be rowdy, yelling and screaming and could be heard saying, "I am the chosen one. I have been granted special powers. I am the gifted one, a special child of God and the most powerful man

on the face of the earth. I am innocent and God is going to prove that, and then I will sue the State." He got to where he would talk to mass murderer Pee Wee Gaskins, who was housed right next door to him.

On cross-examination, Mr. Myers asked the officer, "What kinds of people are kept in that Maximum Security Center?"

"People that nobody else could control. That was the place for the worst in the state."

Another officer told the jury, "We were instructed to make notes whether Bell was talking to himself or to us, and when he became aware that we were doing this, he would remind us to write down the vision he was having."

Swerling asked if he had ever made reference to the Smith girl.

"Yes, sir. One day he started talking to me, saying he was going to marry Miss Dawn Smith. He kept mumbling something about Smith and Helmick, but I couldn't make it out."

The officer read from a note written by Bell on July 11, 1985: "I'm going to leave tomorrow for three weeks vacation outside of town, and I'm taking a blond."

"Later on that night, he told me, 'I am leaving tonight and going to North Carolina, and I know where the grave is, but I won't be able to tell anyone because God is going to erase it from my mind.'"

On cross-examination, Mr. Myers asked the officer, "When he was talking or having his visions, would he remind you to write them down or was he speaking loud enough that you could hear it?"

"He would speak loud but was also aware that we had to make notations."

"So he would remind you to write it down, about the vision that he was having, and those are the notes that you have with you?"

"Yes, sir."

"And when I spoke to you this morning, you said that people put on various acts down in that 'hole' to get out."

"Yes, sir."

The defense called several more psychologists who study abnormal behavior. Again, their results of interviews with Bell showed schizophrenic behavior and that at times he was psychotic or losing sight of reality, but added that people who are psychotic are not psychotic all the time.

On cross-examination, Assistant Solicitor Knox MaMahon asked one psychologist, "Would he know that it is wrong to kidnap and murder the

girl and leave her body rotting in the woods for the purpose of destroying evidence or evidence going away?"

"Yes, but it would also be consistent with a person who knew what would happen if he didn't. Not specifically knowing or appreciating the wrongness of it, but merely for his self-protection."

So again the question of Bell's competency to stand trial was brought up by defense council, and for two hours the trial was stalled for another competency hearing.

Out of the presence of the jury, questioning of psychologists continued both for the State and the defense. Mr. Swerling brought up more of Bell's bizarre actions. "Mr. Bell has been seen sticking his finger in my co-council Elizabeth Levy's ear and calling her Elizabeth Smith, which is Dawn Smith's middle name, and even goes further to calling Ms. Levy his professional cutie pie. He has even tried to kiss me while I was trying to represent him and help him in his defense and blew kisses at me from the witness stand."

Swerling attempted to question Larry Gene Bell again on the stand, but Bell just spoke out, "Food for thought, silence is golden, my friend. I am finished. I am tired, and I am ready to go home. Let's get this over with."

He left the stand and walked back to the defense table and sat down. Swerling asked him, "Are you going to communicate with me?"

"Silence is golden."

Once again Swerling asked, "Are you going to answer any questions?"

Bell's reply, "You get up there and answer them."

Judge Smith said, "If he doesn't want to testify, Mr. Swerling, I can't make him take the witness stand, as you well know."

Myers spoke up, "He is just being theatrical and putting on a show. We are ready to continue and so is he."

Mr. Swerling called clinical psychologist Dr. Diane Ruth Follingstad to the stand, and at the same time Bell turned to her and said, "Off the record you're beautiful. I love blonds in a professional sense."

Dr. Follingstad stated that during an interview with Bell, he mentioned several times that he was going to marry Dawn Smith today and invited her to the wedding. "He believes that he is going to leave the trial and go on a vacation because nobody can really stop him, nor will anybody be able to kill him. That even if he were in the electric chair, he would be able to use his special power to keep the person from pulling the switch."

After a grueling two hours of listening to doctor after doctor, Judge Smith ruled, "I have listened to the testimony of the doctors. Some say he has the ability to understand the proceedings and to assist his attorneys, others say he is psychotic, out of touch with reality and cannot assist with his defense. I also have observed the defendant. Mr. Bell does have a flair for theatrical. He answers questions that he wants to and not those that he doesn't want to. I find that the defendant is fit to stand trial."

The jury returned to the courtroom. Swerling played a videotape for the jury that was made of Bell at CCI during one of his alleged psychotic episodes.

The lights dimmed and the courtroom darkened. The face of Larry Gene Bell appeared on the screen. "This is Larry Gene Bell. My friends call me Gene. Live from CCI." On the tape he jumped from one topic to another. At one time he said, "Dawn is going to marry me, and she is waiting for me to get out." He waved and said, "Hi, Mom, I'll be home for Christmas."

When the tape ended, Judge Smith adjourned court for the day.

Saturday morning, February 22, the thirteenth day of trial, court reconvened at 9:00 a.m. Testimony continued as the jury heard from several more doctors about abnormal behavior. At 12:08 p.m. the defense rested.

The State called a reply witness, John Douglas, director of the FBI criminal personality profiling and consultation program, which deals with getting investigative leads to arrest the person who committed the crime.

Douglas was present at the Lexington County Sheriff's Department the night of June 26 and the morning of June 27, when Bell was brought in after his arrest, and he listened in on Bell's interview with SLED Agent Perry and Lieutenant Davis. Later that day, he also talked with Bell. He was also present when Bell talked with Dawn and Hilda Smith.

Myers asked Mr. Douglas how Bell appeared during this time.

"He was very lucid, very rational, very articulate and was interested in talking to law enforcement."

Mr. Swerling cross-examined Mr. Douglas. "During any of this time did he confess guilt?"

"He confessed guilt by saying that the bad side of Larry Gene Bell may have done this crime."

Redirected, Mr. Myers asked Douglas, "Did you have a plan before he was interviewed for the officers to present this question to him about the good and bad side to give him an out?"

"Yes, sir, we call it a 'face-saving scenario' for providing an excuse for the subject to express his involvement in a crime."

"Did you and the officers bring this up, the 'face-saving scenario,' about was it the other side?"

"Yes, we did."

"Did he take the bait?"

"Yes, sir."

And with that Myers said, "Your Honor, the State rests."

Judge Smith excused the jury for the evening, but before recessing court he spoke to Mr. Myers and Mr. Swerling. "You two have been exemplary in regard to the trial in this case and to your kindness to me. It has been a long trial, and I think that the slight amount of friction in the air at times just shows what good lawyers both of you are."

Mr. Swerling chuckled. "Can we go at each other now?"

Myers replied jokingly, "When we are wrestling, can I call him my ugly teddy bear?"

"Only if he hugs me," said Swerling.

Court convened for the fourteenth day, Sunday, February 23, with final arguments by the attorneys.

Solicitor Myers began,

Need we even talk about Shari's "Last Will and Testament" and the "Sheppard Document," the evidence that broke the case? The telephone number was on that pad. Who was the only one in that house, the only one with a key? Who was the pad left for? The "Last Will and Testament" being written on that same pad…and what did Larry Gene Bell tell the officers while he was in CCI? "I thought I threw that pad away." Does that convince you beyond a reasonable doubt? Is he out of touch with reality? The question is whether or not Larry Gene Bell could follow the law or whether or not he would follow the law. You observed the defendant when I cross-examined him. Was he out of touch with reality then? Did he have control of himself? Is he crazy? Is he out of control, or is he sadistic?

Shaking his head he said, "Cold." His voice then went to a whisper as he leaned toward the jury. "You decide. Listen to the phone calls, and what they tell you, and the interviews when he finally said that was his voice, but it must have been the bad Larry Gene Bell, not the good one, and the FBI agent who said it was a face-saving way to admit it."

In summary, Solicitor Myers spoke softly.

> *When I sit down, you are not going to hear any more from the State on behalf of Shari Smith as to guilt or innocence. We will have rested, as she is resting. She is in a cemetery, and this trial is about who put her there, and if the State has proved to your satisfaction beyond a reasonable doubt that Larry Gene Bell did it, then you take that into consideration. If the State has not proved to your satisfaction beyond a reasonable doubt that Larry Gene Bell did it, find him not guilty and let him go. You are the judges of the facts. Your verdict should ring out loud, the real Larry Gene Bell, and for whom the bell tolls for Larry Gene Bell or for Shari Smith. Speak the truth.*

Mr. Swerling followed.

> *This is by far the ultimate human tragedy. A life has been taken, a young life, and all of our hearts reach out. I am going to do something that probably hasn't ever been done before, a pretty novel way to approach your final argument when you are representing your client, but I am not here to insult your intelligence. I will tell you right now that the State has proved beyond a reasonable doubt that Larry Gene Bell is guilty of kidnapping, and the fact of the matter is, ladies and gentlemen, they got the right guy. They got Larry Gene Bell for the abduction. Mr. Bell's voice is on those tapes. Now, as far as the murder, I don't know. Was Mr. Bell's revelation on that tape the result of what really happened, or was it the ravings of a lunatic who is out of his mind and didn't know what was happening? You will have to use your good common sense, and determine whether or not the State has proved guilt beyond a reasonable doubt as to the homicide. There are two forms of a guilty verdict: guilty or guilty but mentally ill, both of which hold he or she responsible for their acts. You saw Larry Gene Bell on the video and the witness stand. You saw a whacked-out individual who can't think straight, who can't give an answer to a question without rambling on and on and many times doesn't even give an answer. If your verdicts be guilty to kidnapping, which I submit it should be, and murder, which is up to you, then I do ask you for a verdict that speaks the truth that Larry Gene Bell is guilty, but he is mentally ill. He is still responsible for his act under that verdict.*

Bell stood up, and all eyes turned to him as he blurted out, "Judge Smith today is the Sabbath. I think legally in the eyes of God it is my turn to get to the stand."

Judge Smith immediately said, "Be seated, Mr. Bell. Go ahead, Mr. Swerling."

Bell sat down, but three minutes later he was up again with another outburst. "Judge Smith that is enough. I think it is time in the eyes of God. Today is the Sabbath."

Swerling spoke up. "Your Honor, can we?"

Judge Smith interrupted him, "Yes, Madam Foreman, ladies and gentlemen of the jury, please go to your jury room."

He addressed Bell, "Mr. Bell, let me tell you something. I told you the first day this trial started we were going to conduct this trial with you or without you. I am telling you again today. If you continue to disrupt these proceedings, I am going to put you out of the courtroom, and we are going to continue on without you. You understand what I'm telling you, Mr. Bell?"

"Yes, sir."

"All right, Mr. Bell, you can stay in here and behave yourself or you can go back to your holding cell. Which one are you going to do?"

"Legally in the eyes of God, I have already been there over seven months. So in my hand, no price I bring, simply to the cross I cling."

Swerling spoke up. "Your Honor, please, I would move to adjourn. He is not making any sense whatsoever."

Bell jumped back up and made a shocking outburst. "I would like to ask Dawn Elizabeth Smith to marry me."

Judge Smith came right back, "Mr. Bell. Mr. Bell is simply serving his own purposes in his efforts to be theatrical, and this court isn't going to tolerate it."

Bell popped out with, "I think it is time to go to R&R."

"We are going to take a short recess, Mr. Bell, so you can confer with your attorney, but I am telling you again, if you continue to disrupt these proceedings, I am going to put you outside."

After a brief recess, Mr. Swerling said he was compelled to ask for a mistrial because of the prejudice that Mr. Bell's involuntary acts might have on the jury in this case.

Judge Smith firmly said, "I am not going to declare any mistrial because the defendant decides to take self-serving actions. Bring the jury in."

Swerling continued and within seconds, Bell jumped up again. "Judge Smith, legally in the eyes of God, I am tired, and I a hungry."

Judge Smith sent the jury back to the jury room, and again addressed Mr. Bell. "All right then Mr. Bell, I remind you that a few minutes ago I told you that as long as you sit at the table and be quiet you could stay in the courtroom, but if you continued to act disruptively, we would have to move you out of the courtroom. Now, once again, before Mr. Swerling hardly gets started, you again interrupted him. I ask you, Mr. Bell, if you stay in the courtroom, are you going to remain silent until he finishes his argument or are you not going to do that?"

"Yes, possibly."

"All right, if you do have another outburst, then I would have to…"

Bell interrupted, "No, I can't do that. Legally in the eyes of God, I can't. This is the Sabbath."

"You can't do what?"

"I can't stay in here today."

"Are you telling me that if you stay, you would again stand up and say or do something?"

"Yes, legally in the eyes of God."

"All right, sir. Then we will have to have you taken back to your cell and Mr. Swerling will continue. That is your decision as to whether or not you wish to stay in here. All right, you can escort Mr. Bell out of here."

Bell was escorted from the courtroom and Swerling objected to proceeding without his presence, but Judge Smith quoted a U.S. Supreme Court case in Illinois (*Illinois v. Allen*, 397 U.S. 337, 1970) when the accused lost his constitutional right to be present throughout his trial, for the same actions as Bell.

Swerling kept trying, "Your Honor, in light of that, subject to my objection, I ask some assistance. At least have the audio piped in to where he is."

"No, sir. I am not going to at this point set up an intercom system in this case, because it would delay the trial unduly, and we are in the argument part of the trial. Mr. Bell has told his counsel that he does not wish to argue in the case. I can't help but perceive from my observations of Mr. Bell throughout this trial that these are all self-serving matters. Through the entire State's argument, he sat there like a little lamb, and when it came time to talk about whether or not he may be mentally ill, he decided to give us a demonstration. That is my opinion and the jury is not in here."

The jury returned to the courtroom, and Judge Smith told the jury that Mr. Bell would not be present in the courtroom for the balance of the argument by Mr. Swerling. He instructed them not in any way to draw

any presumption from that, and not in any way prejudice Mr. Bell for not being in the courtroom or hold that against him.

Mr. Swerling continued and in summary said, "The judge is the judge of the law. You are the twelve judges of the facts. I thank you for your attention, and I am sorry for the disruptions. Justice in this case, ladies and gentlemen, calls out for one verdict; if you find him guilty, let it be guilty but mentally ill."

Judge Smith had Mr. Bell brought back in the courtroom to be present during his jury instructions. As Bell walked in the courtroom he headed toward where Dawn Smith and her family were seated behind the prosecutor's table. Immediately, Mr. Smith and law enforcement officers jumped up. The officers grabbed Mr. Bell and guided him to his seat at the defense table.

Judge Smith charged the jury, telling them, "You are the sole judges of the facts in this case." He explained the possible verdicts:

> *Count one: guilty of kidnapping, guilty of kidnapping but mentally ill, not guilty, not guilty by reason of insanity. Count two: guilty of murder, guilty of murder but mentally ill, guilty of involuntary manslaughter, guilty of involuntary manslaughter but mentally ill, not guilty, not guilty by reason of insanity. In addition, if the jury should find that the State has proved beyond a reasonable doubt that there was an unlawful killing, but the jury has a reasonable doubt as to whether it is murder or whether it is involuntary manslaughter, then they would resolve that in favor of the defendant and only convict on the offense of involuntary manslaughter.*

After eleven days of hearing testimony, the jury retired to the jury room, and after only fifty-five minutes of deliberation they reached a verdict at 6:20 p.m., Sunday, February 23.

The verdict was read. *State of South Carolina v. Larry Gene Bell*: count one, guilty of kidnapping; count two, guilty of murder.

The courtroom was silent. Solicitor Myers turned to the family and handed Shari's mother a long-stemmed pink rose.

SENTENCING PHASE

After the twenty-four-hour waiting period between the guilt and sentencing phase, court reconvened Tuesday morning, February 25.

Judge Smith made a decision in this case not to allow the photographs and videotape of the crime scene where the body was found because they would be too inflammatory, and the jury had already heard testimony as to the location of the body and description by the pathologist in regard to the condition of the body.

To show a history of Bell attacking women, the State called three of Bell's past victims from 1975 and 1979 for whom he was arrested for aggravated assault and battery and making obscene and harassing phone calls. They all identified Larry Gene Bell as the person they were victims of.

The last call to the Smiths' home on June 22 giving directions to Debra May's body and telling Dawn that she would be next had not been introduced in the first phase of the trial. Solicitor Myers was saving it for this phase to show that Bell had turned his attention to Dawn and begun threatening her, again adding to his history of attacking women. The tape was edited to eliminate any mention of the other victim, Debra May Helmick, so only a portion of the tape was played for the jury.

Dawn testified to that phone call. "He told me that I was going to be next, that God had chosen me to join my sister and that I couldn't be protected all the time."

Mr. Swerling had no questions for Dawn.

Bell stared directly at Dawn during her ten-minute testimony, and as she stepped down and walked back to her seat he grinned and waved at her.

At that time the State rested.

The defense began with a former employee who had worked with Bell at Eastern Airlines. He told how conscientious and nice he was. Prison guards who worked in the maximum-security section where Bell was housed said that he was a nice, disciplined prisoner.

Swerling called Bell to the stand, and before he sat down, he started with his theatrics. "There is a time to keep silent and a time to speak, a time to love and a time to hate." He turned and looked at Dawn, and his haunting voice rang across the courtroom. "Look into my eyes, special angel. It is guaranteed if you will accept my hand in holy matrimony. Will you marry me, my singing angel?"

Solicitor Myers quickly interrupted, "Your Honor, may we excuse the jury?"

Bell started stepping down, saying, "Now is the time to keep silent. Silence is golden, my friend."

Judge Smith spoke up. "Don't step down yet, Mr. Bell. Mr. Swerling and Mr. Myers have more questions for you."

"I won't have any more answers. I am tired. I am cold. I am hungry, and now it is time to go home. I want to move forward with my life. I have many miles to go before I can rest and relax, and I want to take one person with me. I am finished now. I wasn't planning on getting up here and having a talkathon, since I heard the honorable Mr. Myers and yourself talk for days and days."

Then he waved to the audience and blurted out, "There is a fine line between being a genius and being insane."

Swerling said, "Are you insane?"

"No, I'm not insane, but well, I might be, and I might not be."

Judge Smith ordered a break and the jury retired to the jury room.

Again Swerling said, "Mr. Bell is making no sense and not responding to his questions. I would like the court to order another exam to prove his competency, and declare a mistrial."

Judge Smith quickly responded, "He answers what he wants to answer, and when he doesn't want to answer, he starts talking about other things. Mr. Bell is continuing in his own self-serving ways to try and convince the jury that he has some type of mental problem. No, I will not allow another competency exam or declare a mistrial."

Court was adjourned for the day.

Wednesday morning, February 26, Judge Smith's first words were, "Well, it appears that we might be able to finish this case today."

The jury was brought in. Judge Smith instructed Bell to take the stand. Swerling's first question for Bell was, "Do you remember May 31?"

"Yes, I remember Friday, May 31."

"Can you share with the jury anything about that day, now that you do remember?"

"No, there again you are coming across the line to my personal life."

Swerling moved on. "Is there anything about the phone calls you can tell the jury?"

"No, it is nothing in the case at all I can tell the jury that they haven't already heard."

"That is all the questions I have, Your Honor."

Solicitor Myers walked toward Bell. "You say your son is one of your treasures. Does having your son taken away have any bearing on the acts that you committed?"

"I didn't do them."

Myers raised his voice. "Why did you kidnap Shari Smith from in front of her mailbox? Why did you kill Shari Smith? Why?"

"I am not responsible for that."

"Why did you murder her?"

"I am not responsible for that."

"I have no more questions, Your Honor."

Bell asked, "Can I say just one more thing?"

Myers came back, "No, sir, we object to him saying anything."

Judge Smith, hoping he might just say something beneficial, replied, "I'm going to let him go ahead."

Myers came back again, "Then I'm not through with my cross-examination."

The judge said, "Certainly."

Solicitor Myers continued, "Go ahead, Mr. Bell."

"Food for thought, the only thing I am definitely guilty of from the top of my head to the bottom of my feet is lusting for Miss Dawn Elizabeth Smith, and I would like to take her hand in holy matrimony."

Myers spoke up, "Has nothing to do with the case."

Bell came back, "It does have a lot to do with the case."

Myers just looked at him and in a monotone voice said, "If you are so human, like you say, why did you do these things to Shari Smith?"

"I am not responsible for that."

"But you know you need help, now, and you are looking for help right now?"

"I sure am."

"Because your back is against the wall?"

"That's right."

Myers ended, "That's all."

Judge Smith told Bell to step down.

During a break, for the third time in this trial, Swerling requested a competency hearing for Bell and got it. And once again after hearing from the doctors, Judge Smith ruled, "I find that the accused is mentally competent to stand trial. Bring the jury in, please."

Swerling called friends and neighbors of the Bells as character witnesses. They all testified that Larry was friendly and trustworthy, even around children.

Then for Swerling's last effort to save Bell's life, Bell's sister, mother and father told the jury about his personal life. He had been a peculiar child, bashful, timid, insecure and a very private person, to the point of being a loner.

His mother spoke softly as she said, "Larry was different from my other children. He was my youngest boy."

Solicitor Myers had no questions. The defense rested. Judge Smith excused the jury for the day.

The judge then addressed Bell. "Mr. Bell, our law provides that in regard to this last stage we are getting ready to go into, your attorney, Mr. Swerling, has an opportunity to argue to the jury. You also have the opportunity to argue to the jury, but you do not have to make any decision on that now. You can do that in the morning."

Bell spoke up, "Do I get the last word?"

"Yes, sir," Judge Smith answered with a sigh of relief.

"That's fine. I will think about it."

Judge Smith cocked his head and said, "All right, fine. You can think about that overnight, at the gates of hell, of course."

The trial entered into the eighteenth day, Thursday morning, February 27. The courtroom was once again filled to capacity, all wanting to be there for the final episode of Larry Gene Bell.

As the Smith family took their seats next to the prosecutor's table, they noticed that someone had placed a pink carnation on the table in remembrance of Shari.

A few seats away were the parents of Debra May Helmick, knowing that in several months they would be going through their ordeal with Larry Gene Bell being tried for the kidnapping and murder of their daughter.

Solicitor Myers began his summation.

My voice will be the last that you will hear from the State and Shari Smith. As day by day went by, you heard witness after witness and evidence after evidence introduced. You heard the gruesome facts, the sadistic facts, but there is one witness who you did not hear from, who did not testify. She was in the graveyard. What would Shari have said if she was here, if she was sitting in the witness chair? Shari, at 3:28 p.m. at your mailbox did you have the fear of God in you? Where were you taken, Shari? What happened to you? If there was a gun, were you shown mercy? If you were tied down to that blue sheet on the bed, Shari, were you shown any sympathy? What happened until three o'clock in the morning, when you wrote that "Last Will and Testament" at 3:10 a.m.?

Myers picked up the pen in evidence.

When you put your hand on this pen and wrote the words "6/1/85, 3:10 a.m., I love you, my thoughts will always be with you, please don't

let this ruin your lives" and in parentheses "casket closed," what was going through your mind, Shari? Why did she know she would be put in a condition where her casket would have to be closed? What did she see forthcoming? And then, with that pen she wrote, some good will come out of this. If she had never written that letter, we wouldn't be here. The telephone number raised from this page of Shari's letter is why we have a kidnapper and murderer in this courtroom today. She did her part, in her last moments. Thank you, Shari.

There was a hush over the courtroom as Myers talked about Shari's letter. Tears filled the eyes of the Smith family and the eyes of many who sat spellbound in the courtroom.

Myers eventually went over to Bell and shook his finger in his face.

From 3:10 a.m. to 4:45 a.m., where was the sympathy? Where was the mercy? Where was the compassion? Somebody with no human feelings was with her, and the choice, shoot her, drug overdose or suffocation. How was her face and eyes when that tape was being wrapped around, one strand after another? Did she say give me mercy? Did she say give me life? But that was not enough. How long did it take after she was wrapped before total suffocation? Still not enough, drag her body in the woods and leave it. June 1, June 2, June 3, June 4, June 5, very hot, one hundred degrees or hotter. Is that why she wrote "casket closed"? Was she told that?

He turned to the jury.

And the telephone calls. You have heard them, and the one on June 22, what did he say? "Dawn, you are next. Shari wants you to join her. You are next, Dawn." Getting that gratification, that pleasure from more pain. Is that mercy? You have done your job. We have tried our best. Mr. Swerling has done great. Where was Shari Smith? What court was she in? Who passed her law? Larry Gene Bell was the Senate. He was the House of Representatives. He was the governor that signed it. And what crime did Shari Smith commit? Being a loving seventeen-year-old Christian, a talented girl getting her mail, that was her crime. Yet, who arrested her? Police officer Larry Gene Bell, and what court did he take her to? The court of Larry Gene Bell, and who was the judge? Judge Larry Gene Bell, and who was the solicitor? Solicitor Larry Gene Bell,

Courtroom images of Judge John Hamilton Smith, Solicitor Donnie Myers, Attorney Jack Swerling and Larry Gene Bell. *Courtesy of Solicitor Donnie Myers.*

and who was the defense lawyer? Defense lawyer Larry Gene Bell, and who was the jury? Larry Gene Bell was all twelve, and who imposed the sentence? Larry Gene Bell.

Myers's next move was electrifying. He walked over to the jury box and placed a pen on the banister and spoke directly to the jury. "The pen was passed to Shari Smith. Some good will come out of this, she says in her last words. We now pass this pen to you. Sign your name to the right sentence. Let us never again hear that horrible bell ringing of sadism, no conscience, no remorse and no sorrow. Let your verdict bring a sweet sound to Shari Smith."

Following Solicitor Myers's devout summation, Mr. Swerling began his pleas to save Larry Gene Bell's life.

Larry Gene Bell is a sick and mentally disturbed person. He did not ask for his affliction. It was given to him. We don't know why. The doctors don't know why. It has clouded his mind, and there is something in his head that makes him do the things that he does. Mr. Bell informed me that he did not want to argue. I am up here pleading for his life because he can't come up and plead for his life himself. You have observed that man. You have observed that man talk. You have observed him do things inappropriately in the courtroom. You know he is sick. You know that. He committed this crime with a distorted judgment and mind of one who is mentally ill.

Swerling begged the jury not to have another family suffer a loss that they did not ask for or bring upon themselves.

You may not like Larry Gene Bell, but somebody does love him, and it is going to be a tragedy for them, too, just like it has been for the Smith family, and our hearts go out to them. Will you take a pen and sign your name to a sentence of death for Larry Gene Bell, or will you wait until God decides when he should die? I ask you when you go back to the jury room to weigh all the evidence, to talk about life, not about death. I ask you to make a life decision and not a death decision for Larry Gene Bell. Thank you.

Following Swerling's impassioned pleas, Judge Smith told the jury that it was now their responsibility to decide what sentence this court imposed upon the defendant, and explained the two verdicts that they would consider in this case. One was the death penalty, which in South Carolina is by electrocution. The other was life imprisonment.

The jury retired to the jury room on Thursday, February 27, at 11:33 a.m. for deliberations, and after two hours and fifteen minutes they had a verdict.

The clerk of court published the verdict: *State of South Carolina v. Larry Gene Bell:* "We the jury in the above-entitled case, having found beyond a reasonable doubt that a murder was committed while in the commission of the statutory aggravating circumstance of kidnapping, now recommend to the court that the defendant, Larry Gene Bell, be sentenced to death for the murder of Sharon Faye Smith."

Judge Smith called Mr. Bell to the bar. "Mr. Bell, do you have anything to say before I impose sentence in this case?"

"No, sir, sure don't."

Judge Smith then repeated the verdict as recommended by the jury, and sentenced Larry Gene Bell to suffer death by electrocution on the fifteenth day of May 1986, between the hours of 6:00 a.m. and 6:00 p.m.

"All right then, you can take him away." Bell was escorted from the courtroom.

Holding on to each other, the Smith family had heard the sentence with little expression. On the advice of Mr. Swerling, Bell's family was not present in the courtroom when the death sentence was read.

Outside the courthouse, it was rainy and windy with wet, cold temperatures in the forties, quite a contrast from the sunny, blistering one-hundred-degree temperatures that Friday afternoon in May when Bell had taken Shari from her driveway.

After the sentencing, Solicitor Myers told reporters with the *State*, "Larry Gene Bell is the epitome of evil. This is a case that will always stick in my mind. I'll never forget the chilling phone calls."

Bell would not die on his set execution date, May 15, 1986. South Carolina law provides an immediate automatic appeal, which would be followed by years of appeals.

Shari's mother forgave Bell to his face when she met and talked to him after the arrest. "I can't hate you. There is not enough room in my heart for more pain." It took Mr. Smith longer to forgive Bell, but he has forgiven him. Dawn has also forgiven the man who killed her sister.

In July 1986, Dawn Elizabeth Smith was crowned Miss South Carolina and represented the state of South Carolina at the Miss America Pageant in Atlantic City, New Jersey, the following September. She was second runner-up to Miss America. Dawn has written her autobiography, *Grace So Amazing*.

Hilda Smith tells her heartfelt true story of losing her courageous daughter to the hands of a serial killer in her book, *The Rose of Shari*.

THE HELMICK TRIAL

Monday, March 23, 1987, almost thirteen months to the date after Larry Gene Bell was sentenced to death for the murder of Shari Faye Smith, the trial for the kidnapping and murder of Debra May Helmick began.

Because of statewide publicity of both murders, Debra May's trial was moved from Lexington County to Pickens County, 120 miles away in upstate South Carolina.

The Pickens County Courthouse was buzzing with curious spectators. Security was tight and everyone entering the courtroom had to pass through a metal detector.

Law enforcement officers led Larry Gene Bell into the courthouse. His demeanor was much more subdued than on his first day in Berkeley County. He remained silent as he passed by reporters and TV cameras.

Presiding Judge Lawrence Richter addressed the jury panel seated in the courtroom and asked all who had heard about the Helmick case to stand. Only a few remained seated. However, this caused no delay and jury selection began that morning around 11:00 a.m.

An article in the *State* reported that Bell's attorney, Jack Swerling, told reporters, "I hope for a fair trial, even though all jurors will know that Bell is sentenced to die for another murder." Solicitor Donnie Myers told reporters, "If we had to find a county where nobody had heard about it, we wouldn't be able to try it in South Carolina."

After almost two days of lengthy questioning, a jury of nine women and three men were sworn in Wednesday morning, March 25, 1987.

Bell remained quiet during the jury selection, but had one request: he wanted Mr. Swerling to ask the judge not to hold court on Sunday, because he wanted to observe the Sabbath. Judge Richter said he would not hold court on a Saturday or Sunday, but certainly not because of Mr. Bell's request.

During Judge Richter's opening charge, he told the jury that the defendant had pleaded not guilty, and that placed the burden of proof on the State of South Carolina to establish his guilt beyond a reasonable doubt. He instructed them that from time to time he would be asking them to go in and out of the jury room to make some legal ruling so that the evidence or testimony would not be affected. "It's difficult to un-ring a bell, so I would rather you not hear something than have to tell you to disregard it."

Solicitor Myers's opening statements were brief.

Each witness will testify to facts surrounding this case. All these events will evolve around June 1985. On June 14, 1985, a nine-year-old little girl was playing near her trailer with her three-year-old brother. Stated in the indictment, Larry Gene Bell kidnapped this little girl, took her away from her home and family and carried her into Lexington County. There he committed the most heinous crime known to mankind: murder. Debra May Helmick's body was found eight days later on June 22, 1985, in Lexington County. These facts won't be very pretty, but we have to present what the case shows. You are the twelve judges of the facts. The judge is the judge of the law. Combine that together and render a verdict that speaks the truth.

Swerling followed.

You are not going to hear a pretty story. The circumstances of June 14, the abduction and the death of Debra May Helmick, were tragic events. They have torn apart her family. They have torn apart a community. Not only has the life of the Helmicks been disrupted and tragically torn apart, but so has the life of Mr. and Mrs. Bell, Larry's parents, and also Larry Gene Bell's life. You are going to hear facts that are going to make you upset. All that I can ask you on behalf of Larry Gene Bell is to try and set aside those feelings that you are going to get during the course of the trial and decide this case with as cool a degree as you can.

Solicitor Myers called his first witness, Debra May's father, Sherwood Helmick. He told of the events after his arrival at home that Friday afternoon: He saw his daughter, Debra May, and son, Woody, playing

in the yard around the front of the trailer and just a few minutes later his panicked neighbor, Ricky, ran up to the trailer yelling that someone had taken Debra May. He saw Woody crawling around under the bush, screaming, crying and scared to death, and instantly attempted to find his daughter. Finally, he told of the discovery of Debra May's body on June 22. He choked as he told the jury of having to identify her clothing through photographs.

Ricky Morgan, the Helmicks' neighbor, testified to his sighting of Debra May being taken on that Friday, the description of the car, the first letter on the license plate as "D," a physical description of the man and later working with an artist to prepare a facial composite of Debra May's abductor.

Myers asked Mr. Morgan when was the first time that he saw this man.

"When he took Debra May."

"And when was the second time you saw this man?"

"On toward the end of June 1985, when I was watching the news on TV. I saw the man that took Debra May."

"Did they say his name on TV?"

"Yes, Larry Gene Bell."

"Did you tell anyone?"

"Yes, my wife, and then later law enforcement officers. I told them both that was the man that took Debra May."

"Now, Ricky, if you saw that man now do you think you could identify him?"

"Yes, sir, because I saw him take Debra May, and I never forget a face."

"Ricky, please look around the courtroom, and if you see the man that took Debra May, I want you to point him out."

Ricky pointed to Bell. "That man right over there in the brown suit."

"Is there any doubt in your mind, Ricky, that that is the man you saw take Debra May Helmick away on the afternoon of June 14?"

"There is no doubt in my mind. That is the man."

Mr. Bailey and Mr. Collins, Bell's neighbors at Lake Murray, testified to him having a beard during the latter part of June 1985.

Tracy Frick, a hairstylist in Columbia, told the jury that she had seen Bell's picture in the paper after his arrest and recognized him, as she had trimmed his beard and mustache several days before. Records showed that it was Wednesday, June 12, 1985. She had written his name on the schedule as "Gene."

Ralph Beebe, operator of Lakeside Marina located on Highway 378 at Lake Murray, saw Bell on Saturday, June 15, 1985, when he came up to use the family's boat that was stored at the Marina. He described Bell's

beard as being neatly trimmed. Mr. Beebe's testimony instantly flashed me back to the day I saw this person in the phone booth at Lakeside Marina where the Bell family stored their boat.

Solicitor Myers asked both Frick and Beebe if they saw this person in the courtroom, and they both pointed to Larry Gene Bell.

A lengthy in-camera (out of the presence of the jury) discussion followed concerning the admissibility of the evidence and bad acts from the Smith case to be introduced in the Helmick case. After hearing the similarities that intertwined the two cases, Judge Richter ruled that such evidence must be necessary, but only certain evidence would be allowed.

Judge Richter appeared anxious to move on as he called for a ten-minute break and also let the court know that he was not fond of chewing gum. "Take the defendant out, and while we're on this break, everybody in the courtroom get rid of your chewing gum, please. This is not a sports arena. This is a temple of justice."

After the break, the jury returned to the courtroom and the State began presenting testimony and evidence linking Larry Gene Bell to the kidnapping and murder of Debra May Helmick.

SLED Agent Ken Habben testified that during his search, he found a license plate with the number DCE-604 in the trunk of the car that Bell was driving the morning of his arrest, and duct tape in his truck and other places around the Bell and Sheppard residences.

Habben found seven pairs of bikini-style women's underwear in Bell's dresser in his bedroom that were similar to the pair found on Debra May's body. He walked to the jury box, took the panties out of the bag one at a time and laid each pair out on the railing in front of the jury.

Other testimony included clumps of hair found near the body that were microscopically consistent with the known hair of Debra May, and in one clump was a pink barrette. Examination also showed that the clumps of hair had been cut with a dull instrument somewhere between the root and the original tip of the hair. Tests of the residue on the clumps of Debra May's hair showed it to be caused by duct tape or masking tape. The car Bell was driving the morning of his arrest was registered to Bell's sister, Diane Lovelass, who was the previous owner of the sandpit across from the trailer park on Old Percival Road where the Helmicks lived. A Lovelass and Lovelass business card with the address 8504 Old Percival Road was found in Bell's bedroom. Bell told officers the morning he was arrested, "This is because of those two girls."

At the end of the first day of testimony, Judge Richter announced that the trial was moving faster than anticipated and instructed the jury that

they would be sequestered and kept very comfortable. He even said he didn't mind them having a cocktail in the evening at their expense if there was no objection from the State or defense.

Without any hesitation, Myers and Swerling spoke up, "None whatsoever."

Three days into the trial, the once talkative Larry Gene Bell had not uttered any words in the courtroom except to give Judge Richter his name, date of birth and social security number.

As Swerling left the courtroom, the media approached him about Bell's now quiet and passive behavior. He said, "I believe Mr. Bell had a psychotic episode during the Smith trial, but he is now composed. I hope he stays that way."

The State continued testimony the next morning, Thursday, March 26. Pathologist Dr. Erwin Shaw testified that the particular positive finding during the autopsy was to the tremendous degree of decomposition of the head and neck area, making suffocation a prime possibility for Debra May's death.

The jury heard only those portions of the taped calls to the Smith family that had a direct link between Debra May and Shari's murders or directly mentioned Debra May's abduction, including these selections:

June 4, 1985, 9:54 p.m.: "Shari Faye was kidnapped from her mailbox with a gun. She had the fear of God in her."

Solicitor Myers reminded the jury that Debra May was also kidnapped from near her mailbox.

June 5, 1985, 11:54 a.m.: Started with "Listen carefully" and gave detailed directions to Shari's body.

June 6, 1985, 8:57 p.m.: "And I took duct tape and wrapped it all the way around her head and suffocated her."

June 8, 1985, 2:21 p.m.: Started with "Listen carefully now, Dawn," and he described how when he took the duct tape off it took a lot of Shari's hair with it.

Myers reminded the jury that duct tape residue was also found in Debra's hair.

June 22, 1985, 12:17 a. m.: "Have you heard about the Hamrick [*sic*] girl...the ten-year-old...H-E-L-M-I-C-K?" and then, "Listen carefully," and gave exact directions to Debra May's body.

Myers reminded the jury that the calls giving directions to both bodies began with the words "Listen carefully."

This was the last call to the Smith family and the crucial piece of evidence tying both murders together. It was the only call that mentioned Debra May Helmick.

Shari's mother and Dawn testified to the phone calls and to meeting face to face with Bell at the sheriff's office. They both said that after they heard Bell's voice there was no doubt in their minds that the voice was of the same man who had called their home repeatedly.

Solicitor Myers called Debra May's mother to the stand, speaking gently as he asked her about Debra May.

"She was my oldest daughter, blond hair and blue eyes. She was a straight A student and wanted to be a school principal."

He asked her about Friday afternoon, June 14, 1985. She slowly carried the jury through the events of that afternoon.

> *I washed Debra May's hair before I left for work and put two pink barrettes in. She was wearing a pair of white shorts with little pinstripes in them. There were snaps on both sides. Her little t-shirt was lavender with short sleeves. When I went to work Debra May and my son, Woody, stayed at home with my husband. A short time after I got to work, my mother-in-law came and got me from work and told me Debra May had been taken out of the yard. After her body was found, officers brought us pictures of the clothing from the body and the pink barrette found at the scene. The pink barrette was one of the ones I put in Debra's hair that afternoon, and the shorts with the snaps and the lavender t-shirt were Debra May's. The cotton panties were Debra May's, but the silk bikini panties were not.*

Ellis Sheppard testified, as he had in Shari's trial, to his working and personal association with Bell. He also identified Bell's voice as the voice on the tape giving directions to Debra May's body, and how Mrs. Sheppard started crying when she heard Larry's voice on the tape. He told of Bell's obsession with the Smith case and that one of his favorite places to eat was Bill's Grill in Gilbert. "He was cleanshaven the first time he picked us up from the airport on June 3, 1985, and later on into June he had let his beard grow back."

Officers who had arrested Bell the early morning of June 27, 1985, testified that Bell spontaneously said, "You're stopping me because of those two girls."

As the evidence was being presented against Bell, he still remained quiet.

Solicitor Myers called his last two witnesses, Eastern Airline employees who had worked with Bell. They identified the voice on the tapes to the Smith family as Larry Gene Bell. With that the State rested.

Friday morning, March 27, 1987, the fifth day of the trial, the jury was brought in and Judge Richter called Mr. Swerling to present the defense.

Mr. Swerling opened with a stunning statement: "Your Honor, Mr. Bell will not present a defense in this case," and directly followed with "The defense rests."

Judge Richter repeated, "The defense rests, well, that concludes the testimony in this case."

After a recess, Solicitor Myers began his closing arguments.

> *Please remember everything you heard from the witness stand. Remember the phone call on June 5 that started out with "Listen carefully." You know there's something bad coming after that, because right behind it you're going to find a body. On June 22, here comes the chilling sound again, "Listen carefully." What are you going to find after that? Something bad…going to find a body. Hilda and Dawn Smith told you the voice out of Larry Gene Bell's mouth was the voice that told them where to find Shari and Debra May, and on June 8, after Shari's funeral that Saturday, "I'm going to tell you how Shari died again because when I pulled that duct tape off, a lot of her hair came off. Hey, tell the coroner and examiner. That ought to help them out."*

In summary Myers said, pointing to Bell, "Right now, Mr. Bell sits over there, and the law says that he is wrapped in a cloak of innocence. He has a robe of righteousness around his shoulders and it stays there."

Myers then picked up a roll of duct tape and waved it in front of the jury.

> *Wasn't Debra May Helmick wrapped with something the final moments of her life? And was that something not ripped off? I submit that the evidence should rip off that robe of righteousness or that cloak of innocence and strip him to the bone of one verdict, the one thing that speaks the truth and justice and that is guilty. Thank you for speaking the truth and giving us that sweet sound of justice.*

Without delay, Swerling began his closing arguments, saying that the State had called witness after witness who had presented evidence as to Mr. Bell's guilt.

> *At no time did I question any of those witnesses as to what their observations were on June 14, 1985, when Debra May Helmick was kidnapped. I'm not asking sympathy for Larry Gene Bell. I'm not asking you to find him not guilty. I know that may shock some of you.*

My job is to protect Larry Gene Bell, afford him every right that he's entitled to and do it in a dignified manner. I concluded this morning that there's only one verdict in this case that you could come back with, so as his attorney I am not offering a defense as to what happened in this case, but we advise you that down the road we are going to tell you why it happened. Follow your conscience and do what is right.

The judge charged the jury on the law and explained the following verdicts to consider: Count one: As to kidnapping, guilty or not guilty. Count two: As to murder, guilty, not guilty or guilty of involuntary manslaughter.

The jury retired to the jury room at 12:35 p.m., Friday, March 27, 1987, to begin their deliberations. They returned to the courtroom with a verdict at 1:53 p.m. The clerk of court read the verdict. *The State v. Larry Gene Bell*: "Verdict count one, kidnapping, guilty. Verdict count two, murder, guilty."

Bell showed no emotion as the verdict was read and he was led back out of the courtroom.

SENTENCING PHASE

Judge Richter would not hold court on Sunday, so because of the twenty-four-hour waiting period between the guilty and sentencing phase, court resumed Monday morning, March 30, to begin the phase for the jury to recommend life imprisonment or death for Larry Gene Bell.

The State moved forward with several former victims of Bell testifying how he tried to abduct, harass and threaten them.

Complete contents of the tapes of the telephone calls to the Smith family taunting them about Shari's death and leading officers to Shari's and Debra May's bodies were played for the jury. After the tapes ended, Solicitor Myers called Dawn to the stand. "Did you get any more phone calls from this person after the one giving directions to Debra May's body?

"No, that was the last one we received."

"And please tell the court again what else he said to you during that call."

"He told me that I would be next."

With that the State rested.

The jury listened to testimony after testimony of mental experts called by the defense in an attempt to try to show that Bell was mentally ill and didn't know what he was doing when he abducted and killed

Debra May. They described Bell as a very psychologically sick man who had a problem dealing with women and could not control his urges to attack women. They explained that he got sexual pleasure out of inducing pain.

The same video that had played at the Smith trial of Dr. Morgan's interview with Bell at CCI was introduced and played for this jury. The lights were dimmed in the courtroom as the tape began. "Alive from CCI, the gates of hell. This is Larry Gene Bell."

Central Correctional Institute officers testified that Bell was a model prisoner. "He prayed a lot and got real religious while he was there. The first thing he requested was a Bible."

On cross-examination, Solicitor Myers asked the officer, "When someone is in prison, it's pretty common to get that jailhouse religion, before and after the trial, right?"

"Yes, sir, very common."

The defense put up character witnesses for Bell that included neighbors of the Bells on Lake Murray, friends and employees who had worked with Bell at Eastern Airlines. They described him as easygoing, laid-back and a perfect neighbor and friend.

An Eastern Airlines employee said she started writing Bell in prison and prayed for him, and he told her that he had started mail-order Bible courses.

Officer Joseph Rogers with the *Crime Stoppers* program told the jury that someone called shortly after midnight on June 23, 1985, to give a tip in reference to the Debra May Helmick and Shari Smith cases. The caller stated that the picture in the paper looked like Larry Gene Bell, who was housesitting on the Gilbert side of Lake Murray, and he had a history of child molesting blond-headed girls. The officer said the tape giving directions to Miss Helmick's body was played for him, and the voice sounded like it was the same voice as the caller to *Crime Stoppers*.

Sharon Sheppard was next to take the stand for the defense. Swerling asked her about Bell's appearance when he had been housesitting for them when they traveled.

"He was a very well-kept, neat and clean person, and he kept our house accordingly. When we returned from our trip the first time on June 3, he had shaved his beard. He told me he was summerizing it. When we returned the second time after three weeks on June 24, he wasn't his usual clean self. His hair was greasy looking, and he had grown his beard back."

When asked about listening to the tapes of the phone calls to the Smith family, she said, "I got really upset, and broke down and cried. I told them it was Larry."

Bell's sister, Diane, and his father were the next witnesses for the defense. They both said that Larry became depressed and moody when he couldn't get a job because of his past. With that, Mr. Swerling said he had nothing further and that "the defense rests."

The State brought in several reply witnesses.

Mary New and Debra Kattenburg, waitresses at Mr. George's Restaurant on Highway 378 near Lake Murray, testified that Bell and his parents and Sharon and Ellis Sheppard were regulars at the restaurant.

They both said that they had known Larry Bell since the restaurant opened in August of 1984, and when he came in he was always very nice and polite, sort of the "good old boy" type.

Mrs. Kattenburg said she remembered Larry coming to the restaurant on Saturday night, June 22, 1985, because it was the Saturday before she left to go on vacation to Florida the next week. He acted like he always did, just his good old friendly self.

FBI Agent John Douglas testified as he had done in Shari's trial. "We provided him with a proper face-saving scenario, to sort of give him a way out. He told me that he was responsible for these deaths, but it was not the Larry Gene Bell sitting here before me, it was the bad Larry Gene Bell. As far as I'm concerned, it was very effective because he admitted he was involved in the homicide."

Dr. John Dunlap, a psychiatrist who had also testified in Shari's trial, told the jury, "I examined Bell after his arrest and arrived at an opinion that Bell knew legal right and legal wrong, and he realized the consequences of criminal acts. He might not be able to control his thoughts, but he certainly can control his acts. He does what he wants, when he wants, to whomever he picks out to satisfy himself. The big thing was his lack of any remorse or feeling of guilt for what he had done."

Solicitor Myers asked, "Assuming on June 14, out at Shiloh Trailer Park in Richland County, a nine-year-old girl, Debra May Helmick, was playing in her yard about four o'clock in the afternoon. If there had been a police officer standing by, would Mr. Bell have taken the child?"

"No, he was certainly aware that what he was doing was illegal, immoral and he would be arrested promptly."

With that, the State rested, and court was adjourned for the day.

Court convened at 9:00 a.m. the next morning, Thursday, April 2. The parents of Debra May Helmick, Shari Smith and Larry Gene Bell were all present in the courtroom.

Swerling told the court before the jury was brought in, "Your Honor, Mr. Bell advises me that he does not wish to address the jury."

Deputy Solicitor Knox McMahon began the closing statements.

As I sat in my chair earlier this morning, I tried to imagine what Debra May Helmick would look like sitting on that witness stand today. Well, we know she's not here, and we know why she's not here. You have already decided beyond a reasonable doubt that Larry Gene Bell is the kidnapper and the murderer of Debra May. You have heard the facts of this case in the last two weeks. No, Debra May is not here to tell us the enormity of this crime, but I have the faith to believe that she's with us in spirit. Let that give you the strength, courage and fortitude to do what's right in this case, to do what we must do.

Solicitor Myers followed.

My voice will be the last one you'll hear in this whole case on behalf of the State and Debra May Helmick. You've heard a lot of testimony these last two weeks. You've heard things one way, and you've heard things another way. I've got to confess one thing to you. I went to sleep a little bit during some of those doctors. The last thing Dr. Dunlap said yesterday, I was awake then. I heard that because it made the hair on the back of my neck stand up. Remember him saying, "Mr. Bell might not be able to control his thoughts, but he certainly can control his acts. He does what he wants to, when he wants, to whoever he picks out to satisfy himself."

Myers turned to the jury with his hands in the air and said,

You know, what if we take all this mumbo-jumbo these doctors said, and let's throw it in the trashcan, and let's just go to good old common sense. Now, do you really think if somebody is out of touch with reality, and they can't control what they're doing, that Ellis and Sharon Sheppard are going to turn their worldly belongings over to Larry Gene Bell? And Ms. Kattenburg, who served Larry on Saturday night, June 22, when he was in the restaurant for a party. Do you remember a telephone call that he made on that same June 22, that last call, "Listen carefully…Debra May's body." But then Ms. Kattenburg said, "Nothing appeared to be wrong with Larry. He was just his good old friendly self, as normal as he's ever been." And you heard the tapes, him begging for mercy and sympathy. Wasn't somebody begging for mercy to him on those tapes? "Please don't kill my child. Don't kill my daughter." Did he listen? No, now if he's doing things he can't control, why didn't he stop when he drove into that trailer park, and go over and pick up Debra May right then? No, sir, he went down the trailer park scoping things out…drove that car

slowly like a cat looking all around, pawing. Then he comes back up, stops the car, leaves the motor running and the door open. He gets out, walks over to where Debra May is playing with her three-year-old brother. Bends down, talks to her and picks her up. She's only four feet something, and sixty pounds. She's fighting. She's trying to get away. She's fighting until he threw her in the car.

Myers bowed his head, and his voice went into a whisper. "She can't get away. She's doomed. Her tender life is about over. Remember that her mother washed her hair, and put in the pink barrettes? One came back in a clump of hair found near the body." Myers picked up the barrette from the evidence table and held it in front of the jury.

If this barrette could talk, the horror ensued. What did he say to you Debra May? How long did he keep you? What happened? What did he do? He knows, and he wants mercy. He's sadistic. He has no remorse. He wants to do what he can to taunt people, inflict pain and get away with it. He's been doing it since 1975. Don't let him get away with it again. The only thing he is sorry about is getting caught.

Pointing to Bell, Myers said,

Right now, you're about twenty-five feet from a convicted, cold-blooded child killer in this courtroom. Remember how he took duct tape and used it to suffocate both Miss Smith and Miss Helmick? If you go back to the jury room and you have any doubts, hold this barrette in your hand. Put this duct tape in the other hand and close your eyes for a little bit and hold your breath. It's your decision. You have the opportunity to do what's right. If it's not right in this case, it's never right. There is but one verdict in this case. There is but one sentence in this case. Stand strong, and do what's right. If you don't, it will be a blight on the memory of a nine-year-old girl, Debra May Helmick. Thank you.

Mr. Swerling walked over and stood in front of the jury.

Mr. Foreman and Ladies and Gentlemen, I have the unenviable task of arguing for mercy for the defendant, Larry Gene Bell. The solicitor asked for revenge. I ask for mercy. I have never tried to minimize or excuse what happened on June 14, 1985. I have tried to handle this case with as much taste and dignity for the family and the victim and the system as I could. The evidence was overwhelming, and although

147

Larry Gene Bell is responsible and guilty of these crimes, he is a very ill young man. The facts in and of themselves suggest that the person who did this was seriously disturbed and not thinking through what he was doing. Larry Gene Bell is sick. He's ill. He's got a mental disorder, and he's had one for eleven years, but he does have a conscience. Mr. Bell was fighting every minute when these awful tragedies were going on between the bad part of him and the good part of him. On June 23, the day after the Helmick body was discovered, a call came in to the Crime Stoppers *program in Columbia at twelve o'clock that night, and said the person you're looking for is housesitting in Gilbert. He has a history of assaulting young blond girls and his name is Larry Gene Bell. The person who made that phone call was Larry Gene Bell. He was turning himself in, and this is the person that the State says has no conscience, no guilt and no remorse. Larry Gene Bell should go to prison because he is and should be responsible for what he did, but Larry Gene Bell should not be put to death because his acts were not voluntary. They were a result of his mental illness. The death penalty is the ultimate penalty there is. There is nothing more final than a death penalty. Death by electrocution is final. All we ask you for is justice. In this case, justice means a recommendation of mercy, a recommendation that Mr. Bell not be put to death. That he be sentenced to life imprisonment. Thank you.*

Following Swerling's impassioned pleas to spare Mr. Bell's life, Judge Richter addressed the jury. "Ladies and gentlemen, as you know, the defendant, Larry Gene Bell, has been found guilty of murder and kidnapping. It is now your duty to decide whether to recommend that the court sentence the defendant to life imprisonment or sentence him to death, which in this state is by electrocution."

The jury retired to the jury room at 11:39 a.m., April 2, 1987, and began their deliberations. After an hour and seven minutes they had a verdict. Judge Richter asked the defendant to stand as the clerk of court published the verdict: *The State v. Larry Gene Bell*: "We the jury, in the above entitled case having found beyond a reasonable doubt that a murder was committed while in the commission of the statutory aggravating circumstance of kidnapping, recommend to the court that the defendant, Larry Gene Bell, be sentenced to death for the murder of Debra May Helmick."

Judge Richter asked Mr. Bell if he would like to address the court before he imposed the sentence in this case. Swerling conferred with Bell and advised the court, "Mr. Bell does not wish to say anything."

Judge Richter spoke softly.

To the Helmick family let me say I feel helpless in this situation in that the most I can do is impose the sentence that I feel is appropriate under the law. I know it does little to ease the burden of your grief, and I am not unsympathetic to that. My nine-year-old daughter called me yesterday to tell me what her grades were on her report card. I know the loss that I would feel not to have that call.

Judge Richter spoke directly to Bell.

I'm satisfied, Mr. Bell, that you have been accorded every protection of the law. The jury has determined that you must suffer the full measure of the law, and I am satisfied that this jury has done that based solely upon the evidence presented. As I said, the evidence was overwhelming and obviously left the jury no doubt, so it is therefore the judgment of the law and the sentence of the court that you, Larry Gene Bell, the prisoner at the bar be taken to the county jail of Pickens County and thence to the State Penitentiary in Columbia, South Carolina, to be kept in close and safe confinement until the eighteenth day of May 1987. Upon which day, between the hours of 4 o'clock a.m. and 8 o'clock a.m., you shall suffer death by electrocution in the manner provided by law. Take the defendant out, please.

Bell was escorted out of the courtroom and remained silent as he walked down the corridor and out of the courthouse.

Debra May's and Shari's parents were in the courtroom when the verdict was read. Bell's parents were not in the courtroom. Mr. Swerling had sent them home.

Swerling told a reporter with the *State*, "I think Mr. Bell's reaction today shows that he has accepted his fate."

Solicitor Myers spoke to reporters. "We were a little concerned in Pickens County because I understand this county has never imposed the death penalty since the Supreme Court reinstated it in 1977."

Bell would not die on his set execution date, May 18, 1987. The verdict and death sentence would be automatically appealed to the State Supreme Court, as was the appeal for the death sentence that Bell had received a year earlier for Shari's murder.

This verdict again began years of appeals for twice-convicted murderer Larry Gene Bell.

SEPTEMBER 1996

After ten years on death row, all of Larry Gene Bell's state and federal appeals had been exhausted. The State Supreme Court set Friday, October 4, 1996, as the execution date for Larry Gene Bell.

In 1995, the governor of South Carolina had signed a bill that changed the state's preferred execution method from electrocution to lethal injection. Inmates who were already on death row at that time could choose how they would die, electric chair or lethal injection. Mr. Bell chose the electric chair because he said the electric chair is made out of the same "true blue oak" as Jesus Christ's cross, and he believed it was a direct line to the throne of God.

Bell's defense lawyers asked for a competency hearing in an attempt to stop Bell's execution. Judge David Maring heard the testimony from Bell's lawyers and mental health experts. During the hearing, one expert said that Bell believed God had told him to be silent, not to talk with any more doctors and to start a fast. Another expert said that Bell told him, "I didn't kill those girls. I just hid them in God's secret place."

A prison social worker said other death row inmates had wanted to kill Bell because he smeared feces on his cell wall and he refused to flush his toilet because he claimed it was holy water.

After hearing three days of testimony, Judge Maring said, "Larry Gene Bell understands why he was tried and the nature of his punishment, and he can rationally communicate with his lawyers if he chooses. He retains enough related thought to manipulate the system and get the results he

wants. Mr. Bell meets the state's sanity test and can be executed at 1:00 a.m., Friday, October 4, 1996, in Columbia, South Carolina."

Solicitor Donnie Myers said, "I was elated with Judge Maring's decision because I doubted Bell's insanity all along. It was an insanity act."

Present during the competency hearing were Debra May's mother; her sister, Becky, who was now seventeen years old; and Mr. Helmick's mother. Becky said she wanted to go because she wanted to see what a killer looked like in person. "I thought he would look different, somebody that you could pick out from everybody else. When I saw him, he had no look. He just looked like a regular person." Debra May's mother said that Bell never looked her straight in the eye, but he kept turning around and staring at Becky.

EXECUTION

Thursday, October 3, 1996, the State Supreme Court and the fourth U.S. Circuit Court of appeals turned down last-minute appeals from Bell's lawyers to stop the execution. South Carolina Governor David Beasley refused to grant clemency.

Bell took a vow of silence, but still kept rambling that he was Jesus Christ and that his spirit would be resurrected and renewed after his electrocution. He played his games right up to the end.

As the sunny seventy-degree day turned into a breezy cool evening, death penalty supporters began arriving outside the prison. Idle chatter was passed among the curious onlookers: "He knew how to play the system, and that's exactly what he was doing. He's not crazy. He's evil."

Witnessing the execution for the Smith family was Hilda Smith's brother, Rick Cartrette. He said it would probably give him nightmares, but he was doing it for Shari.

Debra May's mother also viewed the execution, even though there was some controversy concerning her being one of the witnesses because this was the execution for the Smith murder and not Debra May's murder.

Mr. and Mrs. Smith did not view the execution but hugged Debra May's mother and softly said to her, "I'm so glad you are doing this for the girls." Mr. Smith said, "I feel sympathy for Bell's parents because he was their child."

During Bell's years in prison, I felt that I was going to be in the crowd at the prison when he was executed, but as I slowly drove up, my heart told me no. I didn't stop. I turned toward home, and I thought of Shari and Debra May. In the peacefulness of my home, I watched the news when the announcement was read: "The death sentence of Larry Gene Bell was carried out at 1:12 a.m., Friday, October 4, 1996."

JUNE 2002

In June 2002, I had the personal pleasure of meeting Debra May's mother. I felt peacefulness as I walked up to her door. I didn't have to knock. She was waiting for me. She welcomed me to her home. I hugged her and said, "I have been wanting to do this since 1985." My eyes watered. A warm comfortable feeling filled the room, and conversation came easily. I shared with her how I had worked in the midst of her nightmare seventeen years before, and how it has stayed with me over the years. I picked up on her protectiveness of Debra May. Tears came to her eyes, but her amazing strength opened up her feelings and the happenings of the afternoon Debra May was taken. I listened. I knew what I knew, but hearing it from her touched me even more deeply.

Debra told me of the first night that Debra May was gone. "I walked outside after midnight and looked up in the sky. It was not raining, but it felt like a misty rain touching my face. I felt like it was my precious daughter, tenderly touching my face and telling me goodbye."

This was one of the few times in my life that I was at a loss for words. I just reached over and lightly touched her shoulder and smiled. She knew where I was.

She went back to when she was pregnant with Debra May.

> *The doctor told me that the heartbeat of the baby sounded like a boy, but I knew better. I had a dream that when the baby was born, it was a girl and her skin was red, and she had reddish-orange hair. When Debra May was born she was red and had the orange hair. She was a good baby, always happy. She only cried when she was hungry, needing a diaper change, cutting teeth or baby things like that. She started walking*

Left to right: Debra May, age eight; Woody, age two; and Becky, age five. *Courtesy of Debra (Helmick) Johnson.*

about a week before she turned a year old. We knew she was really walking before, though, because when we would walk into the room and she was standing, she would sit down and come crawling to us.

December 10, 1997, Debra May's sister, Becky, brought a gift from God into our lives, a baby girl. We named her Debra. I know a part of Debra May was sent back to us through Becky's daughter, my granddaughter, "Little Debra." When she was old enough we told her about her Aunt Debra May and how she was kidnapped and murdered by a man named Larry Gene Bell, and that he was electrocuted in the electric chair. She can tell you that.

And that she did. Little Debra was visiting with her grandmother that day, and she told me her story of her Aunt Debra May. What a delight she was. Debra introduced me to Debra May's doll, Scotty. "I keep Scotty with me to maintain the loving bond with Debra May. Little Debra has

Debra May's doll, Scotty. *Photo by Rita Y. Shuler.*

bonded with Scotty, too. She wants to change his name, but that's one thing I cannot let my granddaughter do."

Another delight was to meet Becky and Woody. I was touched as Becky told me, "I was afraid when I turned nine years old, because I didn't want to be kidnapped, too." And Woody—for a moment I went back to the little three-year-old boy playing in the yard with his sister, and I hugged him. He said to me, "I don't remember much, but I do remember Debra May being taken, and how scared I was." Woody's son, Sherwood III, "Little Woody," has also started bonding with Scotty.

Debra spoke softly as she told me, "I had a hardness and hatred in my heart for Bell for ten years, and I knew I had to let that go and forgive him because it was destroying me. I wasn't the same person I had once been. I couldn't trust. I couldn't love. I forgave him. To this day, Woody cannot forgive the person that killed his sister."

Debra caught my hand and said, "The evil in Bell is what caused it, and I will never know why. One day I will see Debra May again. That's how I make it from day to day, because I know I will see her again."

BIBLIOGRAPHY

Heath, Lieutenant Gaile (SLED questioned documents examiner), in conversation with author, 2001.

Rathbun, Ted A., PhD (Forensic Physical Anthropologist Diplomate, American Board of Forensic Anthropology), in conversation with author, 2001.

SLED investigative case files, victims: Shari Faye Smith and Debra May Helmick.

The *State.*

State of South Carolina v. Larry Gene Bell, court transcripts.

ABOUT THE AUTHOR

 Lieutenant Rita Y. Shuler was supervisory special agent of the Forensic Photography Department with the South Carolina Law Enforcement Division (SLED) for twenty-four years. She interfaced with the attorney general's office, solicitors and investigators, providing photographic evidence assistance in the prosecution of thousands of criminal cases. Her interest in photography started as a hobby at the age of nine with a Kodak brownie camera. Before her career as a forensic photographer, she worked in the medical field as a radiologic technologist for twelve years. Her interest in forensic science evolved when she X-rayed homicide victims to assist with criminal investigations. Shuler received her specialized law enforcement photography training at the South Carolina Criminal Justice Academy in Columbia, South Carolina, and the FBI Academy in Quantico, Virginia. Shuler holds a special love for South Carolina's coast and is a devoted crabber and runner. She resides in Irmo, South Carolina.

Visit us at
www.historypress.net